this is who I am

this is who I am

ROSANNE OLSON

Foreword by Rita Charon, MD

To Sally —
for the beauty in all of us —
Rosanne

ARTISAN

NEW YORK

Published by Artisan
A Division of Workman Publishing Company, Inc.
225 Varick Street
New York, NY 10014-4381
www.artisanbooks.com

————

Library of Congress Cataloging-in-Publication Data

Olson, Rosanne.
This is who I am/Rosanne Olson
p.cm.
ISBN-13: 978-1-57965-363-7

1. Body image in women. 2. Photography of the nude.
3. Women—Anecdotes. 4. Identity (Psychology)
I. Title.

BF697.5.B63047 2008
155.3'33—dc22
2007034446

————

Designed by Stephanie Huntwork

Printed in Singapore

First printing, March 2008

1 3 5 7 9 10 8 6 4 2

To Ted

for your endless support and your poetic heart

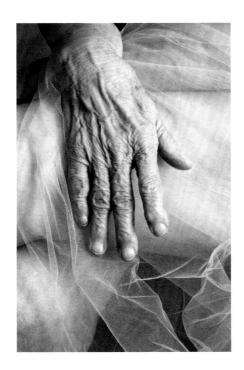

FOREWORD

A woman of age stands erect, looking straight at the viewer, her body barely clad with the delicate drape. A voluptuous figure reveals her curves, not with bravado but with assurance. A mother gathers her two young daughters into a pose of charge and tranquility.

Photographer Rosanne Olson knows how to show viewers that, which without the gift of art, remains invisible. In *This Is Who I Am*, Ms. Olson brings us into the presence of profound and beautiful truths. The women she represents in these arresting portraits give accounts of themselves— in stance, in shadow, in words, in layers of self—and, by communion, tell of living. The complex foldings of outside, inside, shame, and celebration proclaim the enduring and yet always changing turn of being.

The women in the photographs convey their confidence and generosity by appearing for us with dignity and comfort. *This* is what reaches us as we gaze at these moving photographs, not only the physical grace of the subjects but also the giving, the trust, and the sense of being held in respect. More than a book about women or bodies or health or size, this is about being. No matter the discomfort or pain of the past, these women are now *present* to themselves and, as a consequence, to the viewer. Their presence helps us feel our own.

Our bodies know much about who we are and can tell us about our own interior life. Absorbing these portraits, especially in their sequence, slowly encourages us to behold without judgment and to affirm with deep thanks, first the bodies of strangers and then, reflexively, our own. The work enables us to heed what our own bodies might have to tell of ourselves, letting the book dwell on both beauty and truth.

This work of art, this study of anatomy, this book of prayers, this intimate memoir declares a unity of beauty and power—among our hidden and public and myriad selves. Viewers are certain to include men and women of all ages and of all states of health. Those who work intimately with bodies—doctors, nurses, physical therapists, athletes, artists, coaches—will gravitate to this collection of portraits, grateful for the sight Ms. Olson newly bestows on them. Our human practice will be enriched by the photographer's steadiness of gaze, modesty of view, and stillness of regard.

—Rita Charon, MD,
Professor of Clinical Medicine,
Columbia University

In the Company of Many

In a sense, this book arose from my own experiences. As a teenager, I encountered anorexia, which helped give me insight. After college, I worked with cancer and stroke patients as a medical technologist, which taught me compassion. Then came my career as a photographer and writer, which has honed my love of people's stories for the past twenty-five years. But I never imagined a book such as this, until I met Mary.

Mary had been diagnosed with cancer. In the midst of her personal chaos, she asked me to do a nude photograph of her to remind herself and her husband of life before surgery. Her awareness of the fragility of life led to a new appreciation of her body, which she had considered overweight before the diagnosis but which now seemed to her so tenderly beautiful.

When she left my studio, I started thinking: How many of us must wait until something life-transforming happens before we really appreciate our bodies? Must we experience illness or loss to look deeply? We tend to focus on our imperfections rather than on our assets. Influenced by standards imposed on us by the media, we criticize ourselves for imagined imperfections, and we judge others similarly.

I wondered what would happen if I invited women of all shapes and sizes to discuss their feelings about their bodies and then let me photograph them in the nude. My goal was one of complete revelation—not hiding behind clothing but exposing both body and mind. What would we learn about ourselves? What would we learn from each other? Would

we—could we—become more compassionate? Not only toward ourselves but toward one another?

I started the book with a few women, all of whom I knew well, who agreed to be photographed and interviewed. As the project grew, I relied on recommendations from friends and acquaintances for the names of additional subjects. I was looking for physical diversity and a wide range of stories.

None of the women in this book are professional models. There are doctors, lawyers, writers, artists, photographers, professors, and entrepreneurs. They come from different parts of the country, from a host of ethnic backgrounds and ages. Some are single, some married, some widowed. There are young women who speak with youthful clarity and older women who offer views from the distance of childbirth, menopause, illness, and health.

Some of the participants were interested immediately in the project. Others took more than two years to decide. This decision to share of themselves publicly was not easy. But almost all felt they were providing a window for others to learn. There was no monetary compensation, but each received a print of herself as a memento.

When a woman decided to participate, she was given a questionnaire that I had created consisting of several questions designed to provoke thoughts about body image. The first question was, "What do you love about your body?" Most women found this difficult to answer, as if the body were a separate planet. One woman said that for a long time she thought, "My body was sort of a taxi cab that got my mind around. Perhaps this explains why I was capable of starving myself almost to death when I was fifteen."

The majority responded to the questions in writing. Others couldn't find a way to write about their feelings, so I interviewed them. It took one of the participants more than four years to respond. When she did, she divulged her story of being sexually abused as a child, something that shaped her self-image into her early fifties.

Other questions included:

How long has it taken you to arrive at acceptance/love of
 your body?

What frustrates you or what would you like to change?

Has your body let you down (if you feel that it has) or have you let
 your body down?

How have you supported your body?

How have your feelings changed since you were younger?

In general, how do you feel women feel about their bodies?

How do you feel the media have affected how women feel about
 their bodies?

Why did you decide to be photographed?

The resulting photographs and stories are often surprising. There's the
lovely young woman who struggles with eating problems, the lithe dancer
whose dreams of being a professional were ended by scoliosis, the obese
woman who walks with confidence, the eighty-year-old who talks about
the gift of menopause. This isn't a scientific study, but a cross section of
women who have agreed to share of themselves in the hope that other
women might realize that they are in the company of many.

My role in this book has been that of a facilitator. I helped the women
relax in front of the camera and I looked for the beauty within each per-
son, for surely it was there to be discovered. I photographed all of them in
my studio against the same backdrop, with minimal props (using a piece
of sheer tulle for the few who wanted a little additional modesty), and an
upholstered bench or a velvet curtain placed on the floor. And I collected
their stories.

Why would ordinary women agree to participate in a book like this?
Most felt that women need to overcome the stereotypes of "beauty" found
in magazines and movies. They felt that their stories and photographs

would help other women—and men—look at the whole person. One of the participants said, "There is this hope that perhaps others can see you in the way you most deeply want to be seen." Another said, "I would love to help someone else to see that we all need to love ourselves no matter what our size and shape." When ninety-five-year-old Alice told her son that she would be in this book, he exclaimed, "Good for you, Mom!" She gave him a framed copy of her image from the photo session.

While I hope that this book will be of help to others, the process of making it has been a personal gift to me. After five years of working with the women and their stories, I now look at my own body with grateful-ness for how well it functions, how it allows me to move with ease, ride a bicycle, take a walk. I used to wish I were taller or thinner. But now, more than ever, I am happy to be in this world as I am. And when I look around, I feel more appreciation for women I meet in passing, whatever her body shape or story might be.

My hope is that this book will be a catalyst for compassionate conver-sation among women and men everywhere.

—ROSANNE OLSON

this is who I am

Emily, 22

When people look at me, they see a healthy-looking twenty-two-year-old. What they can't see is that my body is a war zone inside. Even with all the doctor's visits, medications, time missed from school, canceled vacations, time in hospitals, procedures, X-rays, and surgeries, the hardest things is when people say, "You look so normal."

Three weeks ago I had the upper lobe of my right lung removed due to complications from cystic fibrosis, a chronic and incurable disease. I'm still getting used to the idea of not being whole anymore; it's weird to think I'm missing a part of my body.

I have to remind myself that it is not my body's fault that I have to go through all this. Having an incurable disease and being chronically ill isn't easy. But this body of mine seems to keep chugging along and pulls through every time.

Looks can be deceiving in many ways. It's important to look deeper than the skin to get the whole picture before you decide what you see.

"When people look at me, they see a healthy-looking twenty-two-year-old."

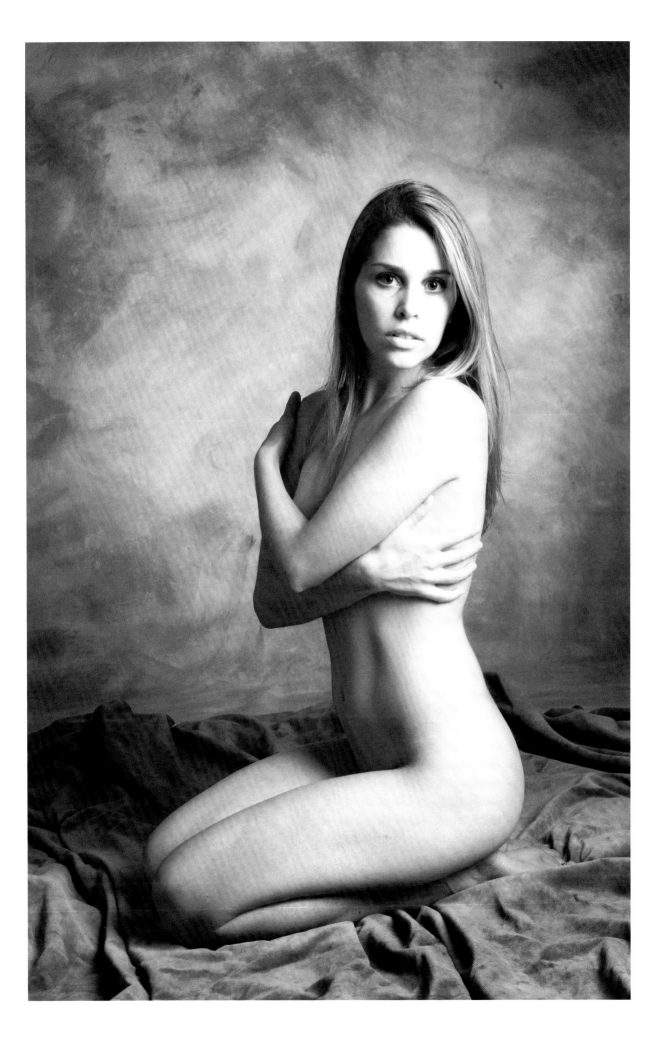

Jenell, 32

I discovered I was fat when I was a third grader in a new school. A class-mate approached me at the pencil sharpener—she was thin as a pencil, by the way—and in a sincerely sweet voice said, " I don't think you're fat." From then on, I was simply fat. Fat. Fat. Fat. My mother took me to diet centers, even started bribing me to lose weight; the last time was a thousand dollars if I'd lose twenty pounds for my wedding! The proverbial lightbulb went off: it's not about me, it's about her. She's embarrassed to have a fat daughter because of how it reflects on her.

Then I got pregnant. Holy shit—I was going to get FATTER! I'd always wanted children, but could I handle what it would do to my body? I just knew I'd be one of the unfortunate ones to gain ninety pounds and people would look at me with shock, disgust, or even pity.

But as the nausea wore off and my belly began to swell, I became more aware of the larger meanings of life and the purposes of our physical bodies. For the first time in my life, I had a legitimate reason to have a big belly! Physical discomforts aside, I love being pregnant. It's as though my body's shape and size are validated by the simple fact that I'm growing a human being inside me.

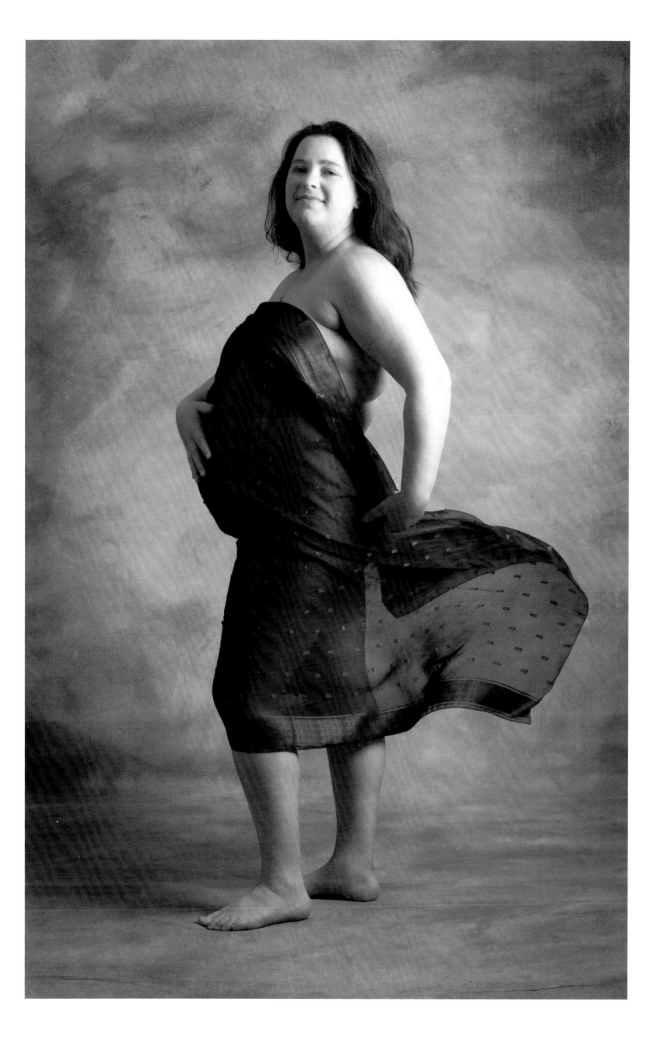

Kay, 64

As you get older, it's really hard to lose weight. I enjoy good food, so it's hard to discipline myself to eat less. I'm sixty-four and have just participated in my eleventh marathon, but I long for the body I had when I was running thirty miles a week. And I'm not getting the looks I used to; I feel overlooked, which has to do with age.

But not too long ago, I saw photos of myself from ten years before, and I remember thinking how great I looked. I realized that I'd better start appreciating how good I look now, because in ten more years I won't look like this!

A couple of years ago, I saw an African American female bodybuilder on a television program. She was slender and muscular and looked to be about fifty-five. I was stunned to find out she was seventy-nine. She looked incredible. She had been doing bodybuilding for only about five years, as I recall. (Note to self: Take up bodybuilding at seventy-four.)

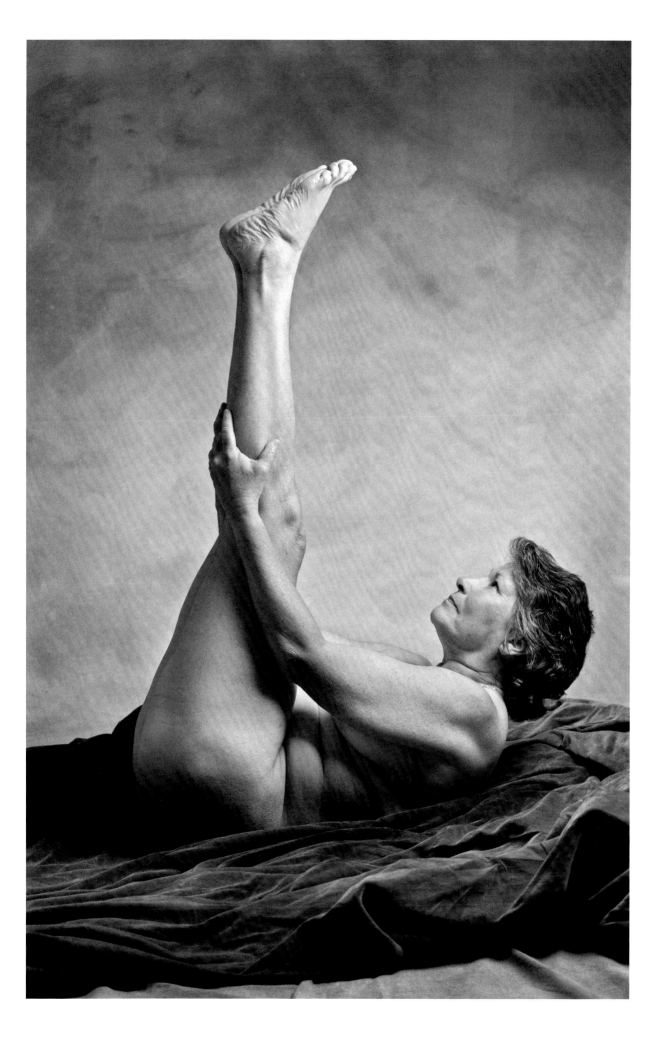

Leah, 45

I love the softness of the skin at the base of my spine right at the top of the small crease that curves down between my buttocks; the shape of my calves and thighs when I lie on my back and raise my legs in the air; the muscles in my right forearm when I play the guitar; the Middle Eastern hint in the shape of my eyes. I love the feel of my body when it's draped over my husband's, the sense of being a blanket for him.

I would like more flexibility, stamina, and physical strength. I would like to have little muscular dents at the top of my shoulders like my rower friend Liz. I would like to have thick, curly, dark-red hair. I would like straighter, whiter teeth and 20/20 vision. I would like to reverse my body clock ten years and with the knowledge I have now make the decisions that would have made all these things happen earlier in my life.

Maybe my Eastern European genetics let me down by giving me a squat, stout body instead of a long, lean, muscular one. Maybe my family let me down by valuing books and creativity instead of physical prowess and competitiveness. Maybe my era let me down by placing me in sedentary work fueled by convenience food instead of in fields laboring to feed myself.

I can see my body aging, the minute lines and beginning of sag in the skin. It's like watching a picture develop in a darkroom, but over the course of years instead of seconds or minutes. I'm both fascinated and repelled. I wonder about lotions and creams and surgical procedures and then wonder at my wondering. Yet at this point, where my body is literally showing the signs of slowing and sagging, I may finally be finding some peace with it. I'm better at knowing what I want it to do and willing to work within its limits. Maybe that's the difference.

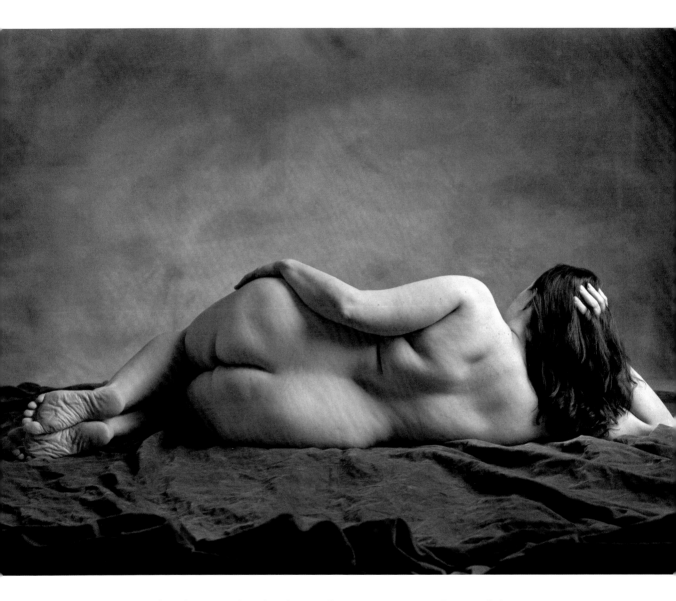

"I've let my body down by not caring for it, like
someone who buys an expensive vehicle, doesn't
bother to read the owner's manual, and then burns
out the transmission through neglect and abuse."

LEAH, 45

Bea, 95

As you get older, it's not easy to think about your body. Its functions aren't as good as they once were. You can't do as many things. I'm finding that the brain is a particular problem. I met a woman today and I was going to remember her name, but I didn't. Perhaps the brain says, "Hey, I just can't put any more in."

But my body has been a reliable source of energy for most of my ninety-five years. I stay fit by walking a lot. And I stay intellectually fit by reading a lot. (I used to be a librarian.) I appreciate my vitality.

It's been a diverse and interesting life. What I'd say to younger women is to develop both physical and mental skills so you can enjoy your whole being.

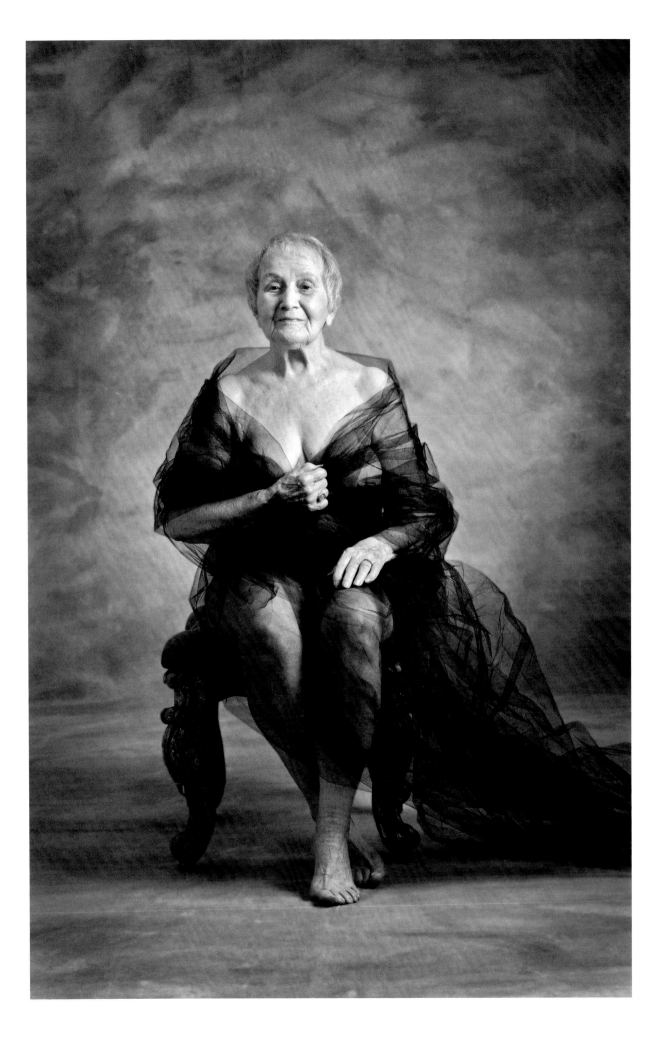

Kristine, 33

I am not sure if I will ever accept or love my whole body. It's a battle. But being pregnant has given me a new view and understanding of what my body is capable of. I initially hated the changes I went through during the first three months. Eventually my mind and body surrendered, and now I can honestly say I love the change due to my son. For the first time in my life, I love my belly, inside and out!

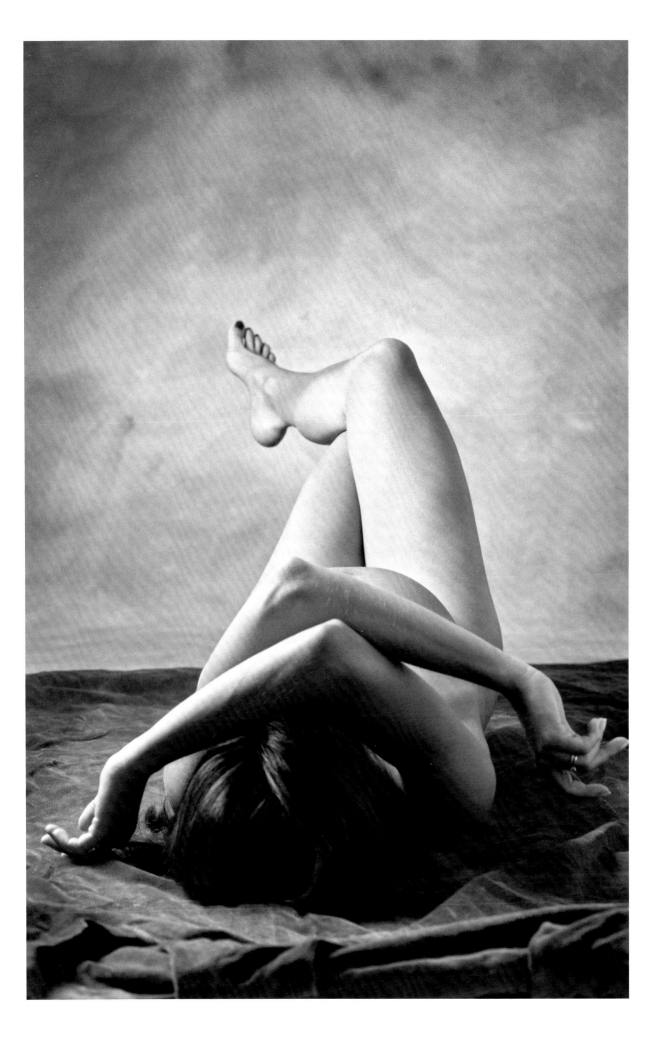

Raechel, 38

I'm Chinese, I'm black, I'm white. I love my brown skin. I love how I'm limber and strong, small but capable. And what I love even more is all the things I can feel with my body—the rain, hot stones, water, being touched. When I look in the mirror I see a strong, life-loving, sentimental, melancholic woman who comes into herself every day. My Guatemalan girlfriend who is like an auntie told me that whenever I feel blue, I must look at myself in the mirror, throw back my shoulders, lift my heart and breasts high, and shimmer! This usually makes me laugh out loud, even if I'm on the verge of tears. It reminds me how I want to be in the world.

I was raped at eighteen and again at twenty-five, something I kept very secret. We carry all these things inside of us—our secrets and our shame. It's been about twenty years, but it never goes away. Every time I start some kind of intimate relationship, I have to see how I feel. But I've learned to transform my sadness and loss of innocence. I've learned that it's important to rise above being a victim and reclaim myself.

I'm grateful to the amazing women in my life—my mother, my "sister-mamas"—who've taught me how to be a woman, how to make peace with myself, and help heal the wounds of the past. This is not the time to live timidly, to be afraid or ashamed.

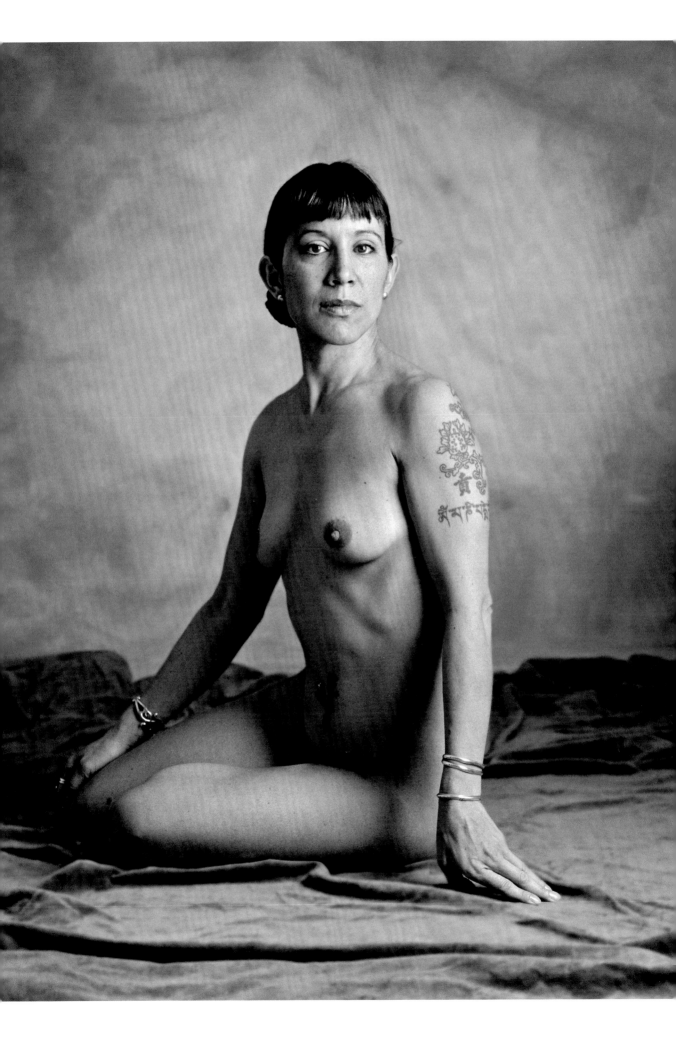

Kiyoka, 31

I think American women are more accepting of the various shapes and sizes of women's bodies, whereas Japanese women are more critical—maybe because there's only one race in Japan. Japanese women try harder than they should to be skinny; there are always diet issues in magazines and on television.

I don't have to work at being skinny. I can't gain weight, even though I eat a lot. I hate it when people tell me to eat when I'm already eating. I do like exercise, though. I feel so light, so it's easy for me to move my body.

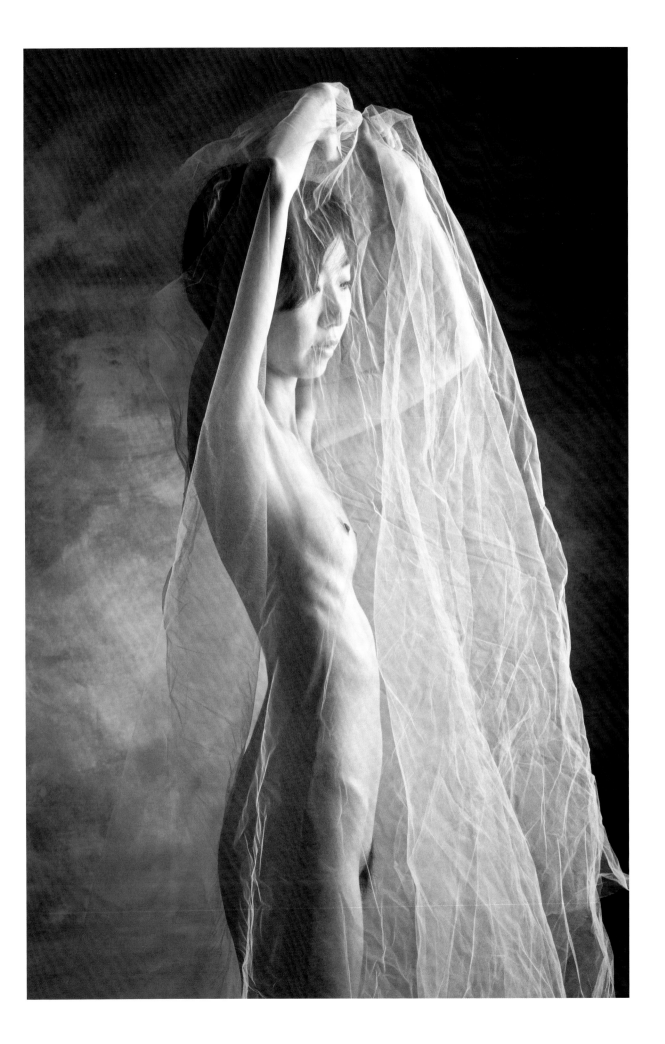

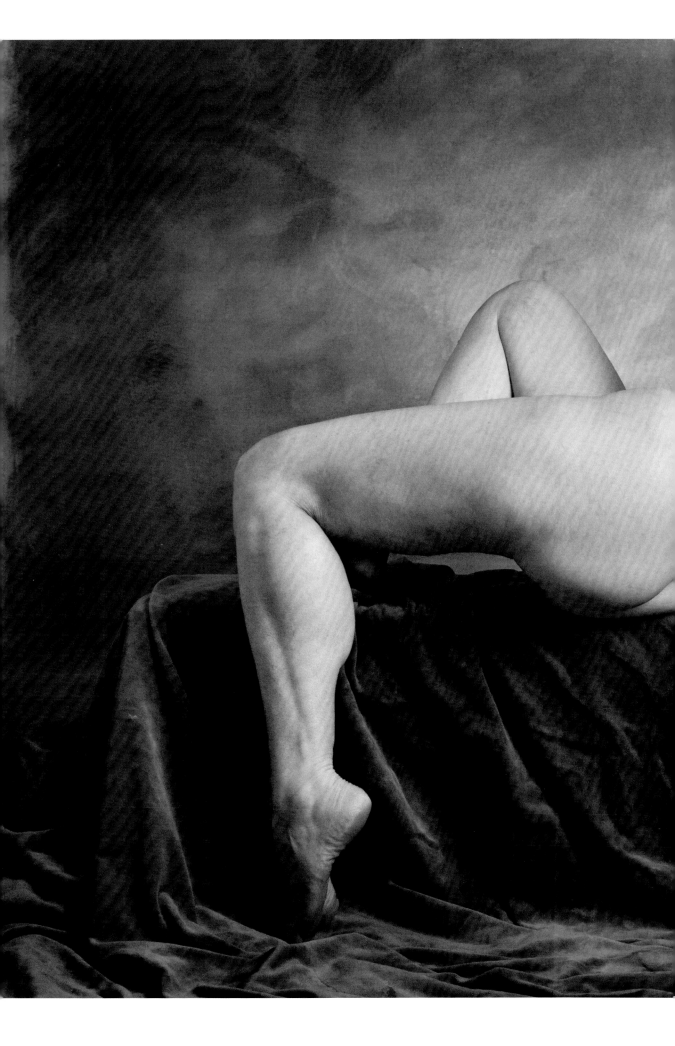

I love being comfortable in my body.

It has a certain grace that is distinctively mine."

BARBARA, 51

(page 62)

Michelle, 58

When you're heavy, you become a nonperson. People look at you and think, "She's out of control" or "She doesn't have any willpower." Too much weight makes them uncomfortable. People believe that overweight people don't deserve love, either toward themselves or from someone else. A man once walked up to me and asked, "When's the baby due?" I've had people say, "Why would you have a boyfriend?"

I try to present a nice appearance, but the choice of clothes for larger women is terrifying. It's either the fat lady at the mall with sequins and pictures of kittens and puppies all over her chest or else a large copy of a skinny person's fashion (with hideous results).

In 2005 I was diagnosed with stage one breast cancer—which, by the way, I consider a blessing. In order to minimize the risk of recurrence, I decided to embrace health in every possible way. I lost seventy pounds, started dancing six times a week, and began to meditate.

Soon after finishing radiation, my hair fell out from stress. Now I was finally a normal size, but I was completely bald! I have no hair, no eyebrows, no eyelashes, and breasts that are two very different sizes. I look like a seal—a cute seal. Once again, I've become a nonperson. When I go out without my wig, all people see is my bald head, and it scares them. Their eyes quickly dart away. Luckily, I've found that the more I open my heart to other people, the easier maintaining my weight and adapting to being bald becomes. We all have something. Mine's just more obvious.

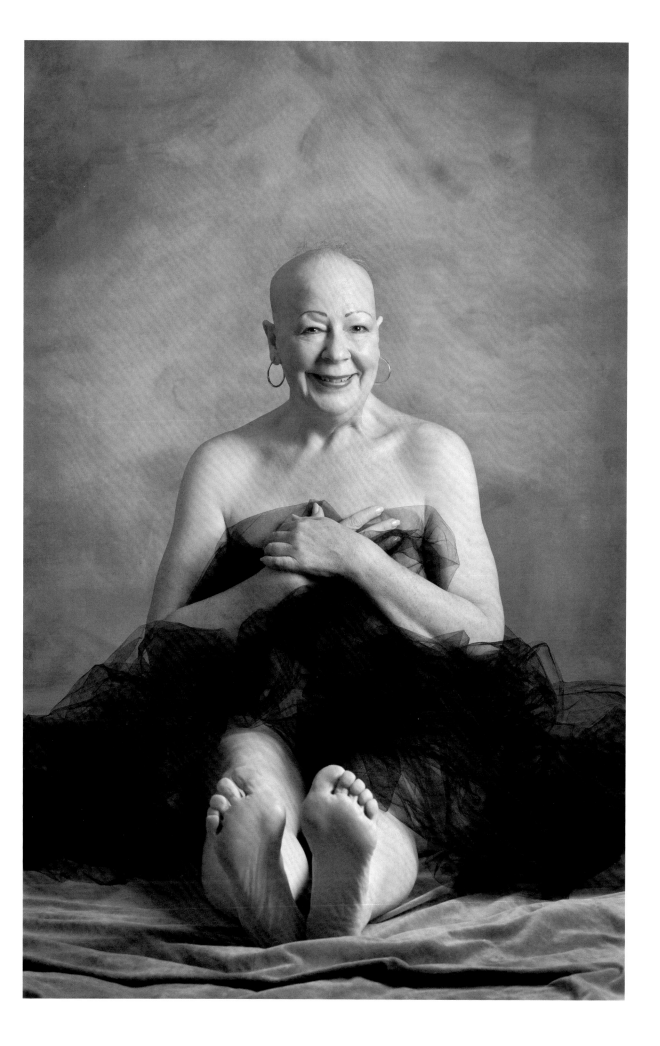

Kia, 37

As an adopted child, it was difficult to accept the beauty that others saw in me. I viewed myself as the ugly duckling because I didn't look like anyone else in my family. It wasn't until I found my birth mother that I could begin to see what others had been telling me most of my life. During our first meeting, we looked at photos of her in high school, and all I could say was, "Oh, my God, we look alike." I identified with her grace and her style, and suddenly I saw myself more clearly. I now have a sense of inner beauty that I try to incorporate into my own sense of style.

Giving birth to two beautiful daughters and seeing myself in them, I can now appreciate my body (and all its curves). I make a conscious effort to teach my daughters to love themselves by speaking positively to them about their bodies, and by telling them on a regular basis that they're beautiful. I want them to be able to face whatever challenges are ahead of them as African American children, who I hope will evolve into strong African American women.

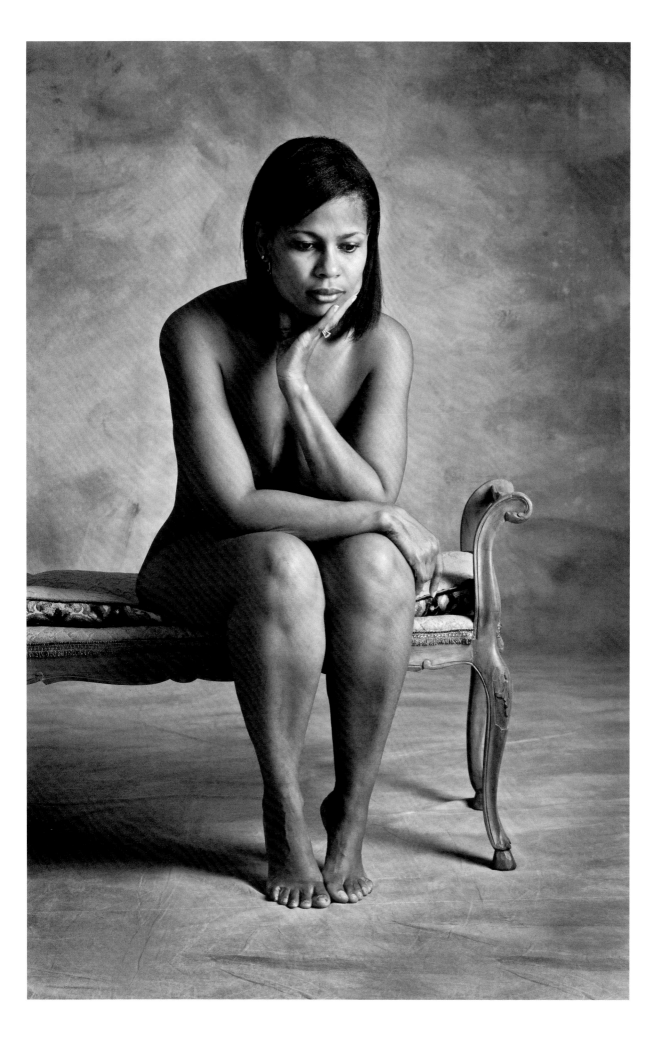

Jan, 88

I used to be a dancer. I was with modern dance companies as well as commercial companies before World War II. I'm happy that my body still moves around well, though I've never particularly loved it. The most you can ask is that you keep in shape.

I think women worry far too much about their bodies and then don't do anything about it. I've always been busy doing body things like dancing and swimming and hiking. Now I walk the dog, and I still do some stretching before I get out of bed in the morning.

I was diagnosed with early-stage Alzheimer's over a year ago. My long-term memory is pretty good but my short-term memory is affected. It's frustrating and depressing, but I say get over it. If you dwell on it you can really get into a state of mind where everything is wrong. That's a big waste of time and energy. I'm trying hard not to think about myself these days, and I also don't care what other people think about me.

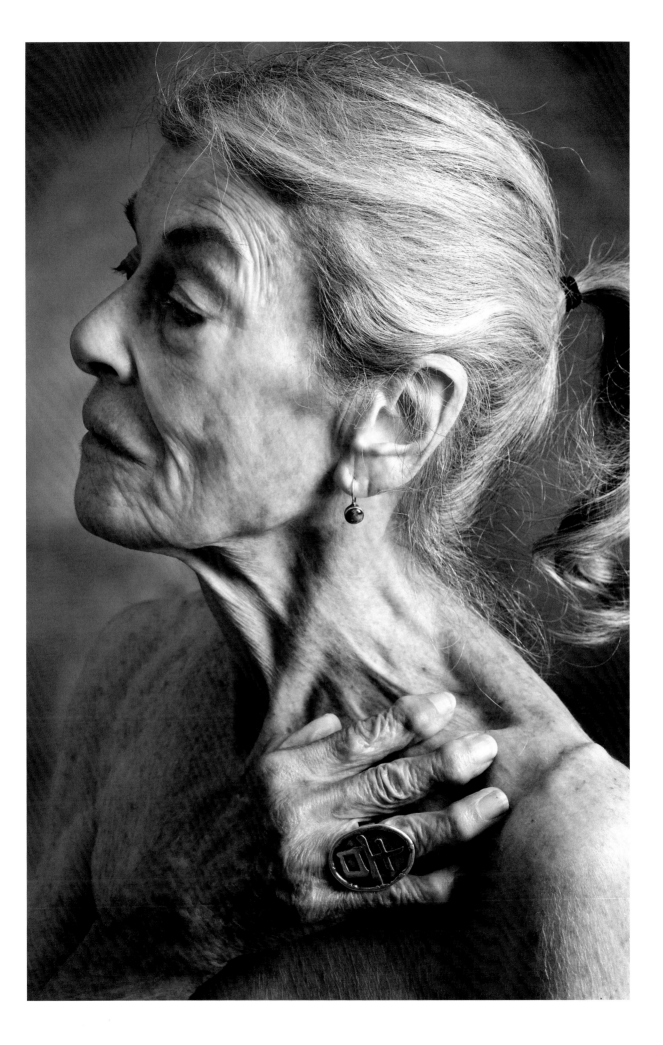

Nisi, 49

As a young teen, I was very alienated from my body—I disguised it and wouldn't dance. I had no sensation in my nipples. Then at age forty-five I began to experience unexplained pain in all four quadrants of my body. Two years later I was diagnosed with fibromyalgia, a chronic medical condition whose etiology is mysterious. Basically, it means that the question I face each morning upon waking is not "Will I be in pain today?" but rather "How much pain will I be in today, for how long, and over which parts of my body?" But with time, as a matter of survival, I've come to identify more with my body, and to celebrate myself as a physical being. I'm so sensitive to stimuli and so responsive to the sensory input of the world around me. I love how I can walk around and interact with the world.

"My advice to younger women:
Sit with your legs apart if you want to.
Stride like a man if you want to. Don't
slouch—hold yourself up straight."

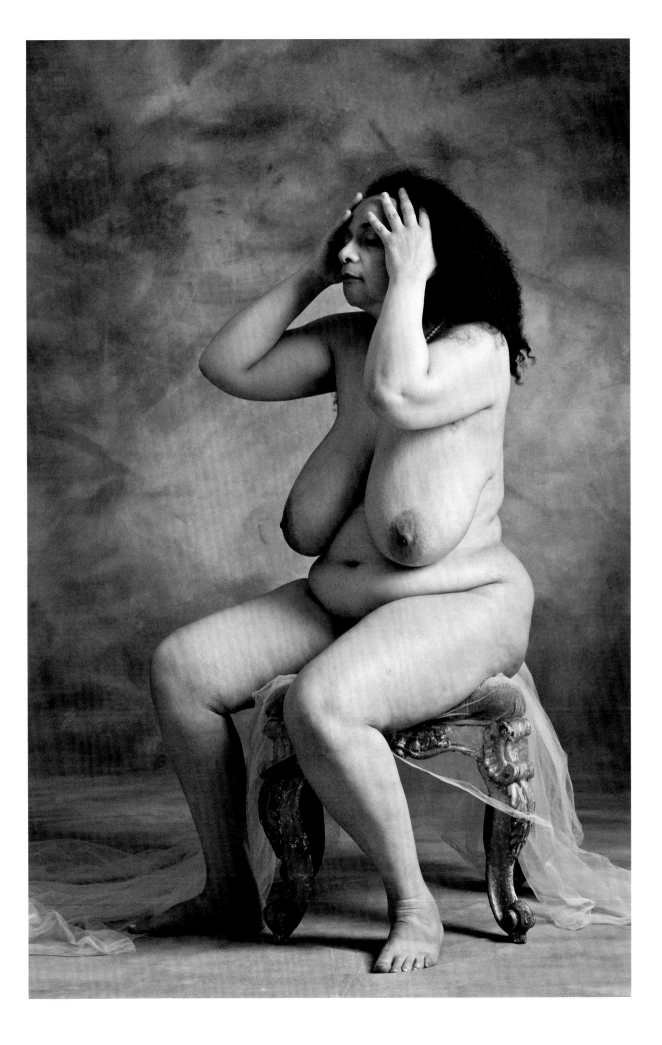

Gail, 48 · Gabrielle, 19
MOTHER AND DAUGHTER

When I was in my teens I was a constant dieter. I thought I was too fat. I hated the size and shape of my breasts—too big. I thought my nose was too long. The list of criticisms seemed endless. Now I have the same body, only it's older, saggier, and weighs about five pounds more, and I feel none of that self-loathing. Instead, I feel tenderness and gratitude for what this body can do and has done for me. I truly love my entire body; it's basically healthy and strong. It's taken many years, but now when I look in the mirror, I think, "Pretty good for forty-eight years old!"

From the time my daughter was born, I was determined to help her know and listen to her body—to see it as a source of information and vitality rather than something to starve or surgically alter in order to be more "beautiful." I've given my son the same messages. He's thirteen and we'll see how it plays out for him. —*Gail, 48*

When I was little I watched my mother put on her makeup, flirt with my father, and chat with her girlfriends. I also watched her cook and enjoy delicious food, be tough when she needed to be, and cry when she was sad. I didn't know it, but my subconscious was taking it all in.

I remember the thrill in adolescence of discovering that I could be sexy and womanly if I wanted. But I often feel discriminated against because I have big breasts. It's frustrating to feel that I have to cover up parts of myself that other women don't, just to be seen as a self-respecting, intelligent person and not as a sex object. My mother has taught me to take pride in my sexuality and to give myself the respect I deserve. It's like your mother always said, for people to love you, you must first love yourself. —*Gabrielle, 19*

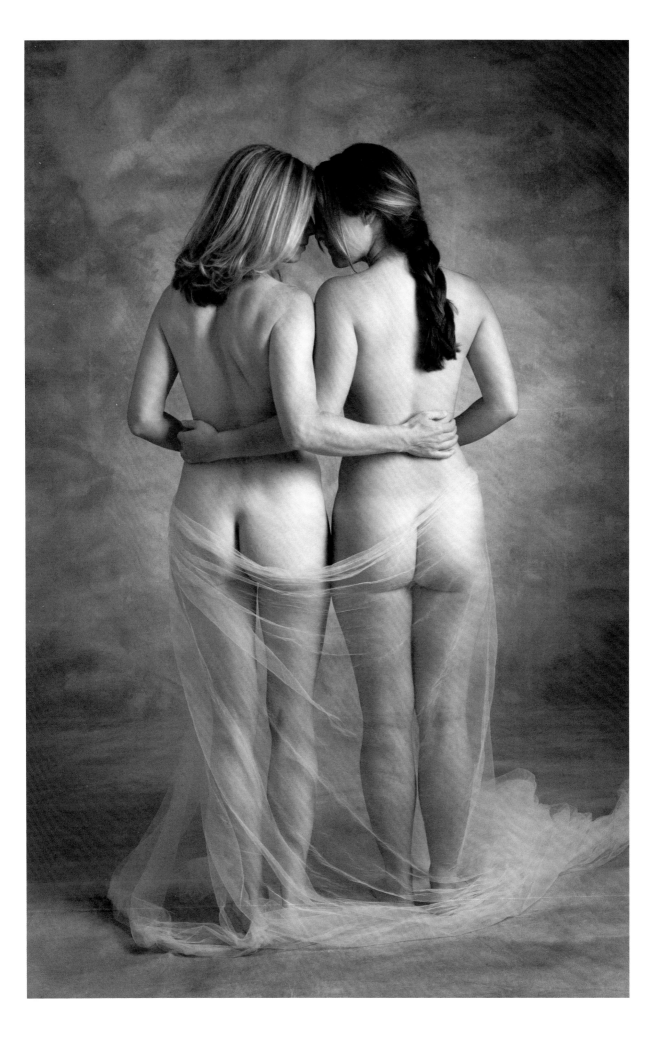

Pat, 33

I was a fat kid between the ages of eight and twelve and was constantly teased. I hated it, and I think I had very low self-esteem because of it. I lost the puppy fat in my teens, only to put on the freshman fifteen (and more!!) when I came to the United States from Singapore. I think that's when I became really body-conscious. Images of reed-thin models epitomizing the "ideal woman" permeated the media, and everyone seemed to be obsessed with physical beauty.

I was never satisfied with my body in college; my weight was always yo-yoing, especially between the seasons. I became obsessed with what I ate, sometimes gorging, sometimes starving, and sometimes forcing myself to puke when I felt guilty for eating too much. Fortunately this didn't become a disease.

Also, most people mistake me for college-age now, at thirty-three. I know I should be flattered, but I feel that people don't take me seriously or give me the respect I deserve. I could always dress up and wear makeup if I wanted to look older, but that's just not me.

Now that I'm thirty-three and married, I've finally found peace with my body. I'm not as slim as I was when I was living in Singapore, but I love my body for all its flaws (I do wish I had longer legs!), although I still start to panic a little when I can't fit into my jeans. Ask me how I feel once I have children.

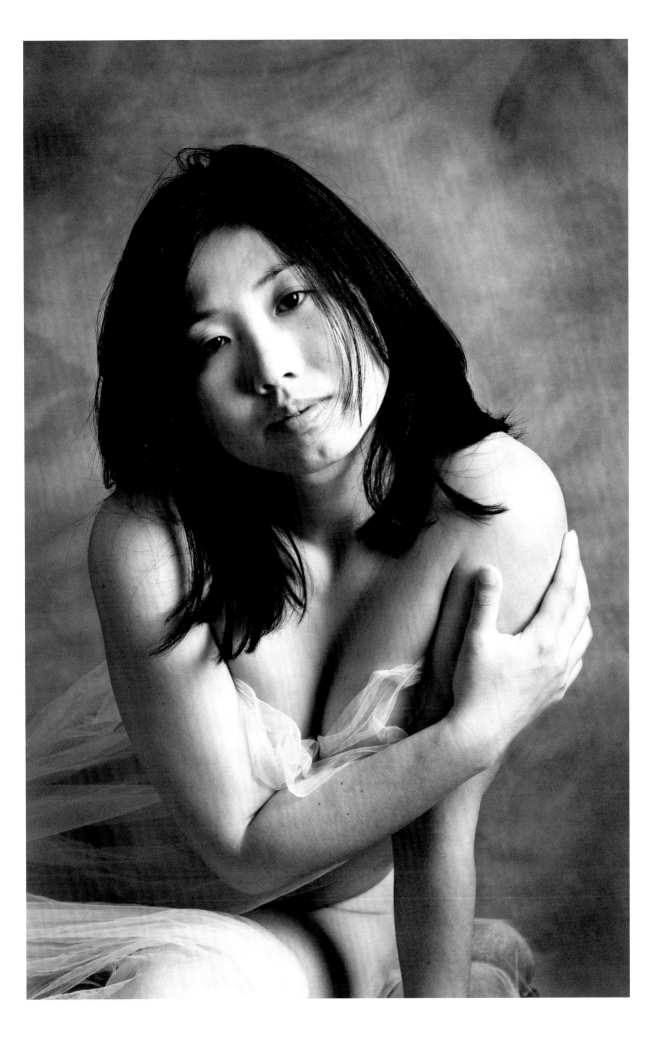

Sabrina, 43

When I was growing up, there weren't many voluptuous women of color on television or in the media. This made it difficult for me to be proud of my body. And though there are no really large women in my family, they have never made any negative remarks about my body, no matter what size I've been. I think this is a very common attitude in the black community.

As a teenager, I began to hate my body. I had very large breasts, the biggest in my class. I was verbally harassed by men, young and old. What people don't know when they look at me is that I'm a wonderful vocalist, but my self-esteem was damaged for a while because people would focus on my breasts when they first saw me on stage. Twelve years ago I had breast-reduction surgery. It had a profoundly healing and positive impact on my life.

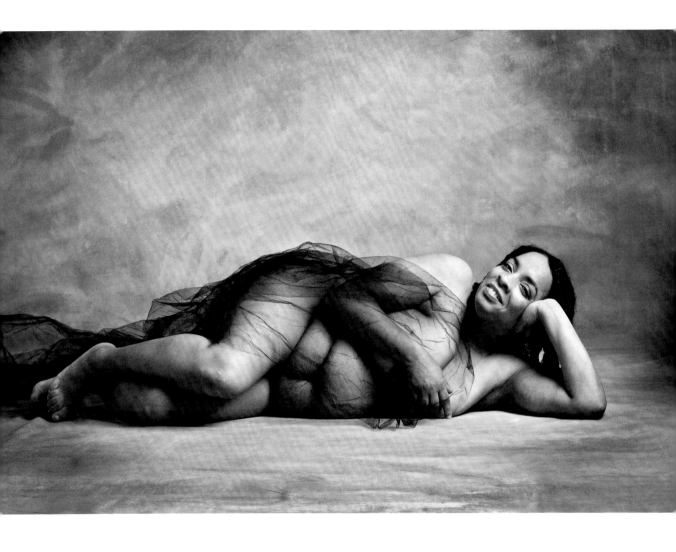

Nancy, 60

For a long time I took the Cartesian view that there was a mind-body separation. My body was sort of a taxicab that got my mind around. Perhaps this explains why I was capable of starving myself almost to death. When I was fifteen, I was five foot three and weighed sixty-four pounds.

Today I see myself as an integration of body, mind, and spirit. Feeling spiritually whole erases that old mind-body dichotomy and makes you feel pretty damn fine to boot! And marrying a man who totally, without condition, loves me has made me feel like my body is wonderful. My regret is that it took me into my fifties to feel this way and achieve a healthy body size. Gravity has, alas, taken its toll. But this is who I am at sixty, and I'm happy with myself.

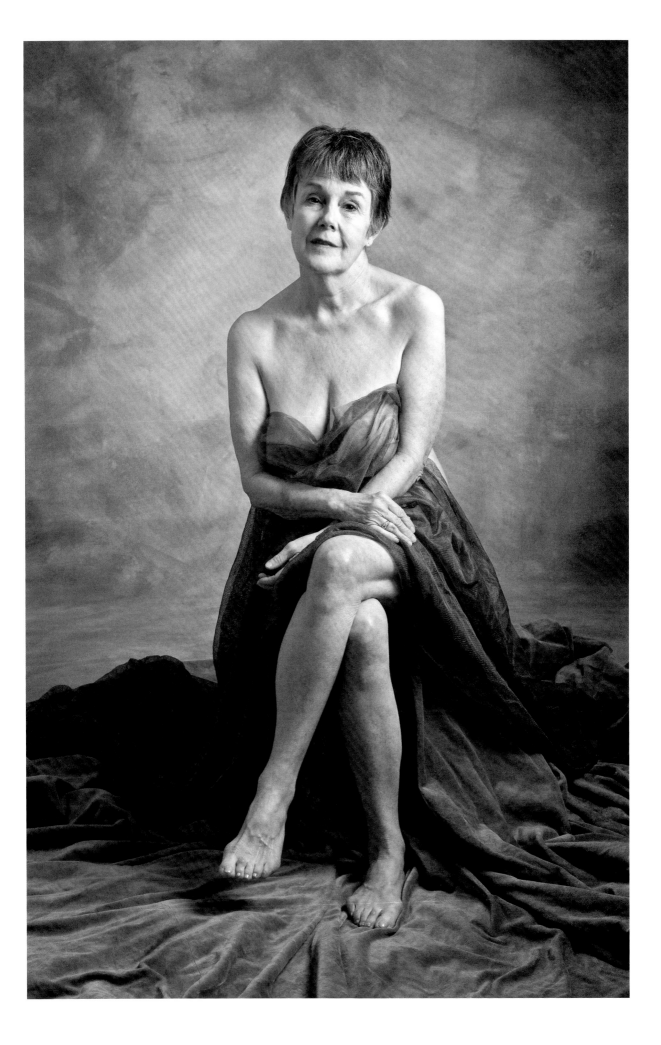

Faye, 38

I want to decorate my body with images that make me feel good when I look at myself. A favorite uncle of mine who disagrees with my tattoos likes to say that the body is a temple. I reply that my tattoos are the stained glass of my temple.

Because of my tattoos, I've been discriminated against socially, and when people look at me they can never guess what I do for a living. When you're tattooed, you get placed in a category, and spiritual healer is not usually one of them.

I'm actually insecure about my body—not with my skin but with my shape. That shocks most people who know me. I'm perceived as a strong, confident woman. I was talking about my weight to a friend recently and she said, "When I look at you I don't see an overweight woman, I just see Faye." She was surprised to hear that I feel so insecure about my body.

There's one more thing that I almost forgot to mention—I'm a survivor of domestic violence. For more than five years I was physically and emotionally abused. I was kicked, my eyes were blackened, my head was put through walls and heaters. I was pulled around by my hair with my three-month-old daughter in my arms. I used to wear eye patches to cover the black eyes. I never honored myself enough to protect my own body. Now as a survivor I've put this behind me and am learning how to make sure it will never happen again.

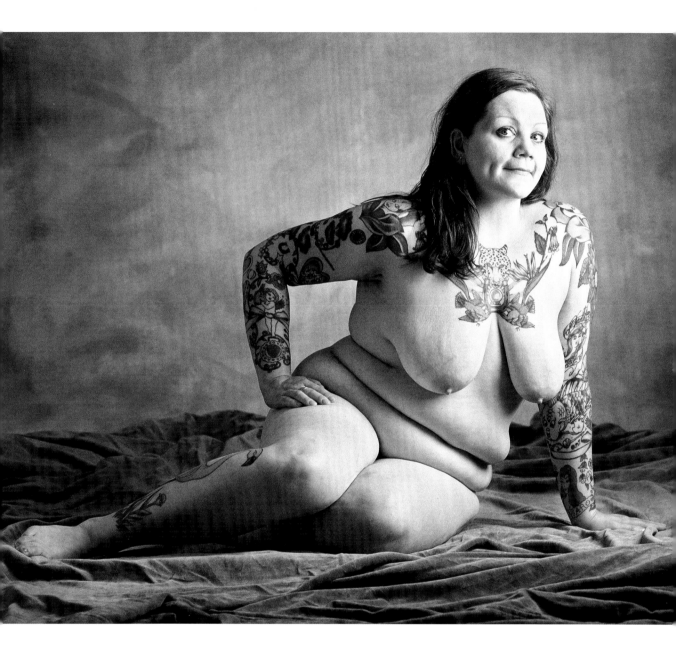

Constance, 80

In a restroom on the university campus, a handwritten sign on the mirror reminds the user that "Everyone Is Beautiful," as if trying to counteract the negative feedback most of us feel on viewing our own image.

Though I tend to avoid mirrors, I like catching a glimpse of my shadow in action when I'm walking or riding my bike. Most of the time I'm pleased that my body works pretty well, bore healthy children, and is relatively slow to break down as it ages. I try to give it what it needs: water, food, exercise, sleep. Since I retired, I can take a nap whenever I want, and I've had fewer long-lasting colds. I'd say menopause is God's gift to women. I rejoice in freedom from the responsibility of reproduction.

It's clear to me that I would have had more professional opportunities as an astronomer if I were a man. I like to imagine a system where everyone is reincarnated, switching gender at each reincarnation but retaining some memory of what it's like to be the opposite sex. When I tried to deal with an egotistical colleague or a pompous administrator—almost invariably male in my day—I found it entertaining and soothing to visualize his next incarnation, maybe in the ninth month of his fifth pregnancy.

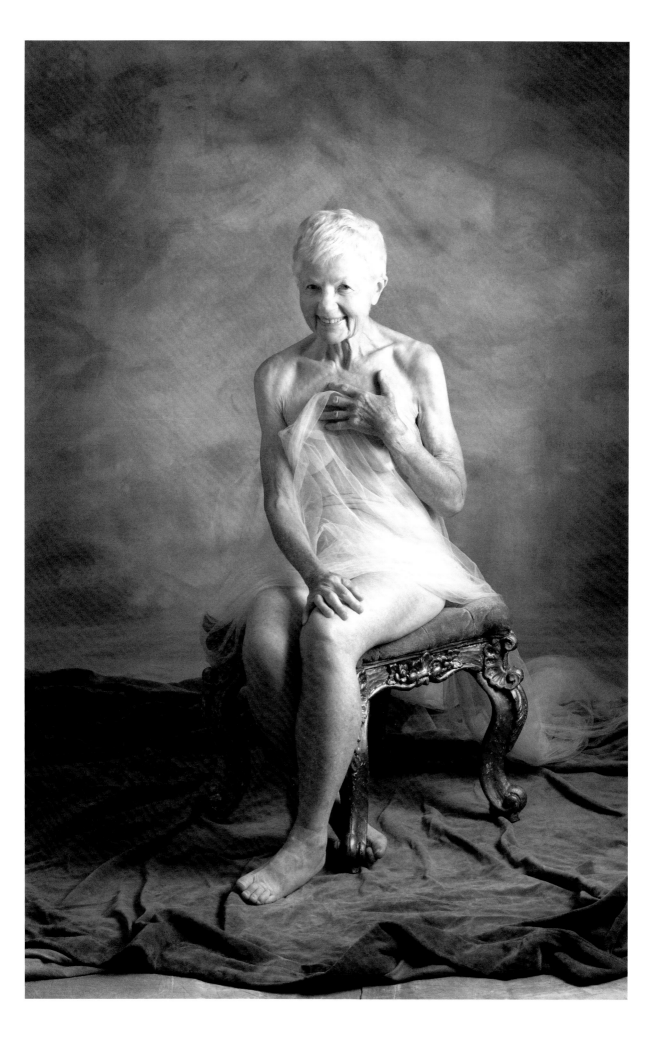

Carol, 50

The mirror in Maine is a skinny mirror.
I turn to scrutinize each angle.
There's a simplicity in its form, a compactness.
My body has become as lean and graceful as a birch tree.
This mirror is gentle on me, I think.

To understand this better,
I move over a few steps to the dresser mirror
and discover it is nearly as kind to me as the skinny mirror.
I stare at its reflection
and then, as if I can't quite believe its generosity,
I stare down at the real thing.

I take measurements with my hands of the outsides of my thigh
and bring them up to the reflection for comparison.
My hands move like calipers,
first down, then up again, down, then up.

I think my mirror at home is a fat mirror.
Maybe this reflection is the real truth.

And then I wonder about truth,
and how like a trickster, its face keeps changing.

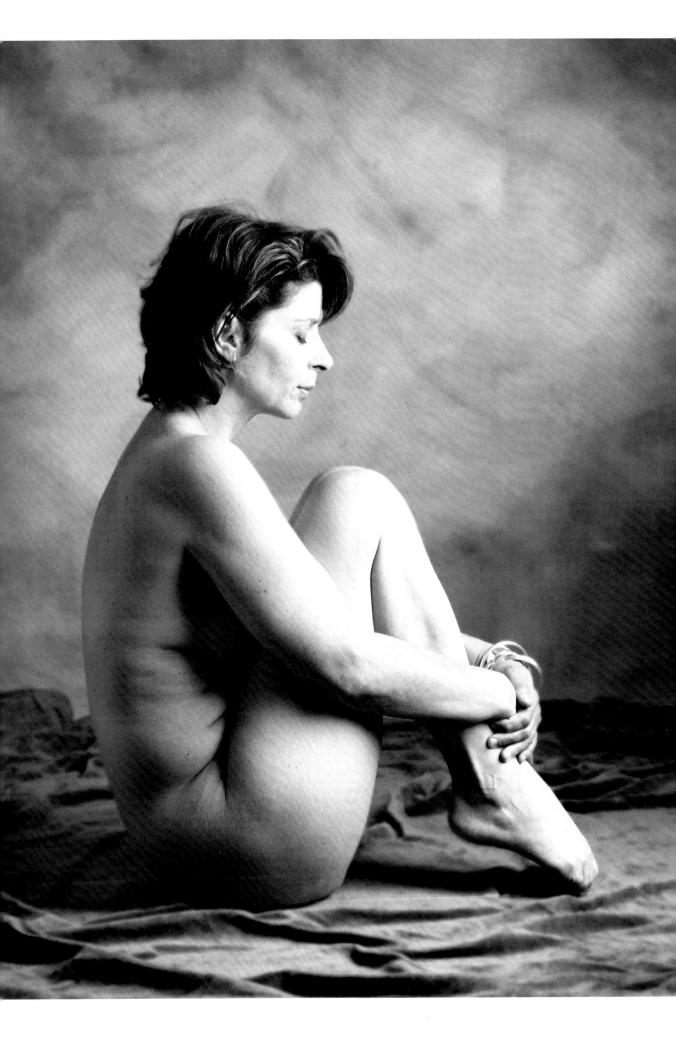

Silja, 35

When I was younger I fixated on what I thought my flaws were. A boy in elementary school told me I had hairy arms, so I shaved my arms for a while. I thought I had droopy breasts, so I wore all manner of uncomfortable bras. I thought I had short legs (okay, I kind of do), so for a while I wore heels all the time. I thought I had unruly hair (true again), so I shaved much of it off throughout my teenage years as a punk in Los Angeles. But I don't regret any of that, because I carved out a distinct path for myself that helped me through a lot of difficult times. I've really made a lot of progress, because I can look in the mirror on most days and think of myself as being beautiful and strong. I love that this feels like a body of my own creation as much as it does a body that I was born into. My "creation" has to do with a kind of re-creation: from hating the body I was in to reclaiming it through tattoos and through molding myself somewhat into the kind of curvy shape that feels good, healthy, and sensual to me.

I believe the advertising industry has done more to damage women's self-concepts, happiness, and body image than almost anything else, including pornography and parental and peer influence. Music videos seem to run a close second; it breaks my heart when I see younger girls modeling themselves after the scantily clad candy girls you see in videos these days or after what they've seen airbrushed in a fashion spread.

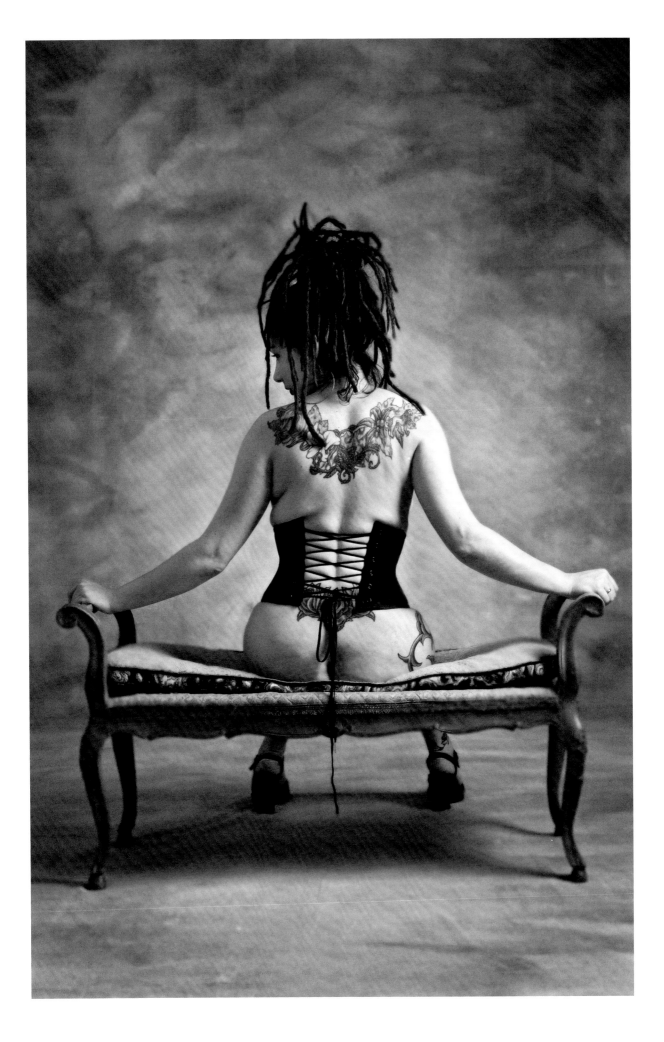

Dee, 74

Love is never a word I would use to describe my feelings for my body. Long ago I admired it for its strength and litheness; bemoaned its wide shoulders and big bones; seven times been amazed at its ability to create and nurture a new life for nine months and return to normalcy. I feel annoyed that my taste buds enjoy far more food than my body needs, but I am grateful for my body's resistance to disease and general malaise.

Sometimes I wonder how much I would weigh if I still had my tonsils, my adenoids, my appendix, my uterus, one ovary, the two inches of height lost to osteoporosis, and my right eye that I lost at age ten. Would they be as heavy as the weight of sorrows that inhabit my body from time to time?

I look best in the early morning. Nightgown off, there are no indentations left from clothes attached too tightly at breasts or waist. Gravity has not yet pulled down the stomach muscles, and the sagging skin is not so obvious, especially when I don't put on my glasses.

Yes, that's best of all. No glasses, just the slightly blurry reflection of the image in the mirror.

Does everyone get brown "age spots"? I'm told the sun has damaged my skin—broken capillaries, light brown, slightly raised spots, dark brown, nonmalignant spots, and oh, yes, thin skin. I don't think my hands belong to me. They look at least eighty, with veins that protrude almost above the tendons.

I used to feel defined by my artificial eye and my mind. Today the eye no longer matters, but my mind still does. I can't bear the thought that my body could go on living without my mind to guide it, relying on others for all of life's necessities.

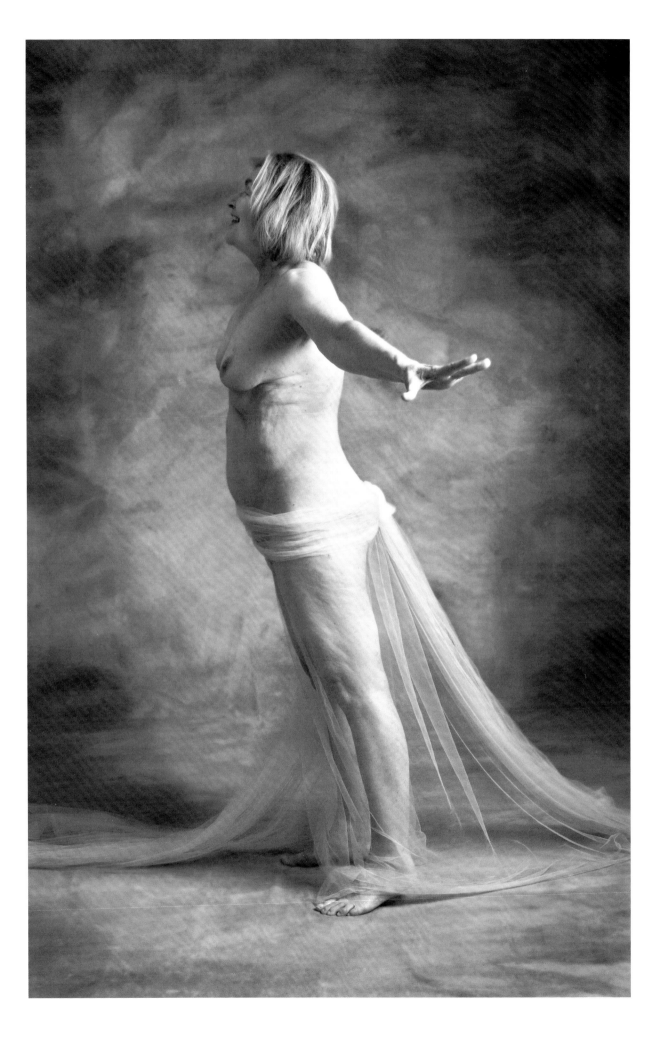

Shonagh, 42

For my girls: How to be in the world—

It's my intention to raise you with a reverence for your whole being. The body you are in is your radiant temple. It has taken me a long time to come to that realization for myself. I see the intense pressure in our culture to be beautiful and sexy and thin, and I see so many women and girls who reject their bodies because they don't fit this mold. Try to remember that all of that is illusion. It doesn't define you.

Don't take your amazing body for granted. When you get sick, listen to what it is saying. When you feel intense emotion, feel where in your body the emotion lies. Be aware that what you feel inside will be reflected outside, both physically and energetically.

Think about how you are going to nourish this exquisite vessel. Be sure to exercise regularly in some way that you enjoy. Be comfortable in your sexuality, and don't let anyone shame you for it. Know that when you choose to share your body with another, the experience can be deep and sacred. Look for a partner who can honor his/her self and you. You have been gifted with life in a body. Open your heart to the wonder of that.

All my love,
Mom

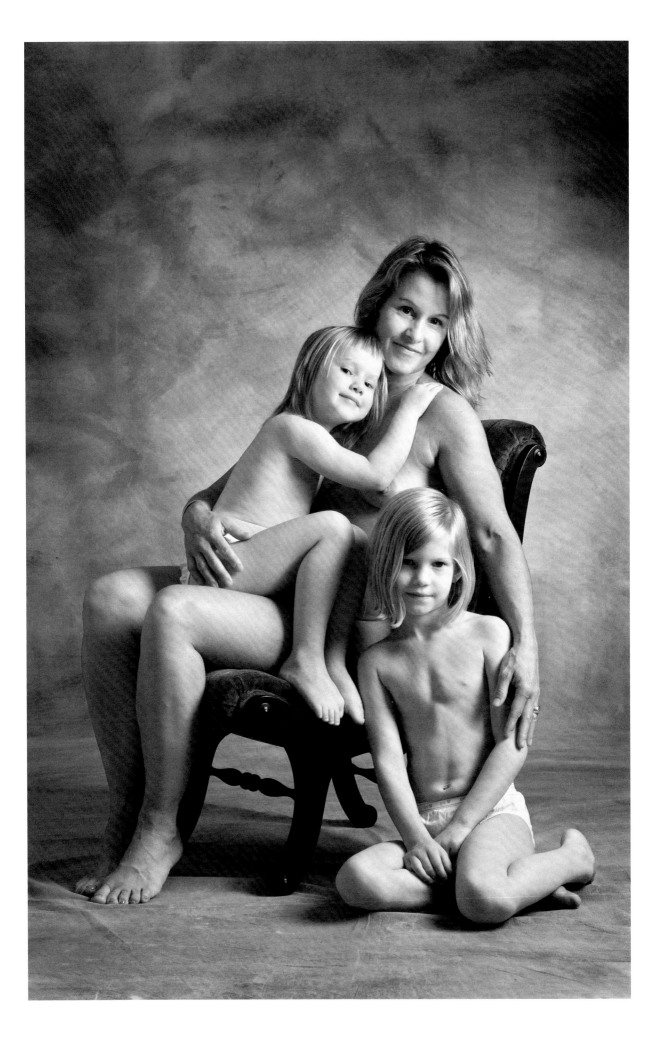

Donna, 39

I was stick thin until my mid-twenties. My family is from New Orleans, and during summer visits down south, my aunts would tease me and say that I needed "meat on my bones." A few years later I tried modeling and was told I needed to lose weight (even though my doctor said I was at the low end of the ideal weight range for my height). The mixed messages left me conflicted.

Now, though I wish my stomach were flatter and I were about sixty pounds lighter, I've adopted an "it-is-what-it-is" attitude toward my body, accepting it for the most part. I still secretly wish I were thinner, but I have finally started to wear shorts and bathing suits in the summertime!

My advice to younger women? Don't get caught up in the media hype or what society tells you is beautiful. Beauty comes in all colors, shapes, and sizes; you have to feel it inside first. Be proud of your heritage and of who you are.

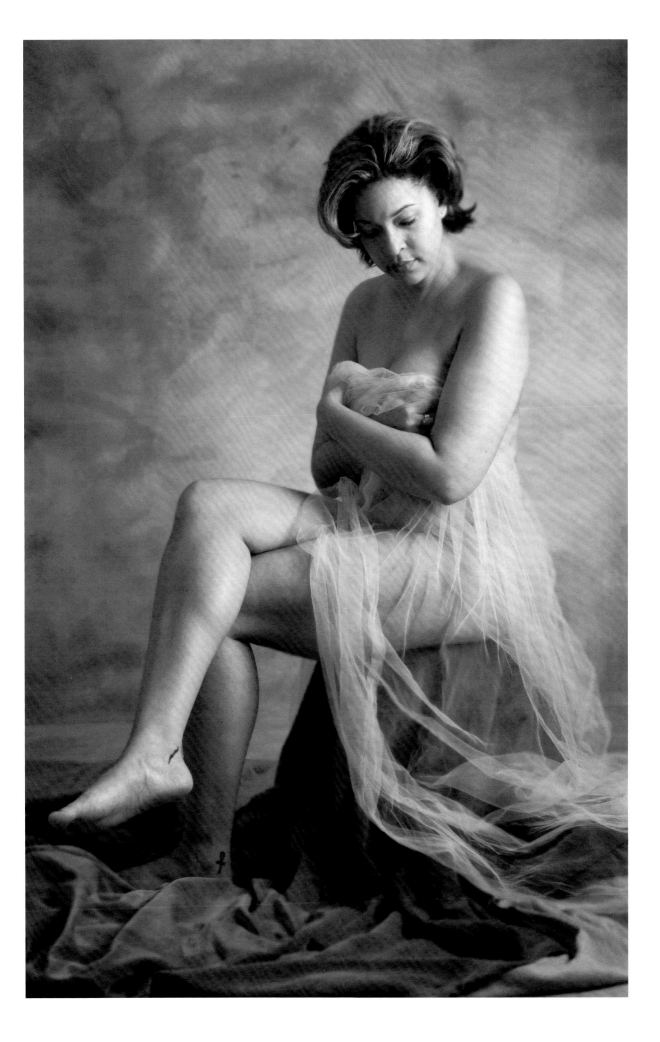

Lorena, 33

I'm anything but the classic Chinese beauty. Whereas Chinese women are supposed to be porcelain white like a China doll, lithe, and petite, I'm curvy, muscular, and tan. I stick out like a sore thumb with my full lips, hips, and ample bottom. My mother always chided me for playing out in the sun and getting dark like a "peasant." She wanted me to stay indoors and study, be pale and wan. It was not to be. Instead, I defy the traditional Chinese ideals. I worship the sun and play sports hard. I enjoy having a strong and fit body.

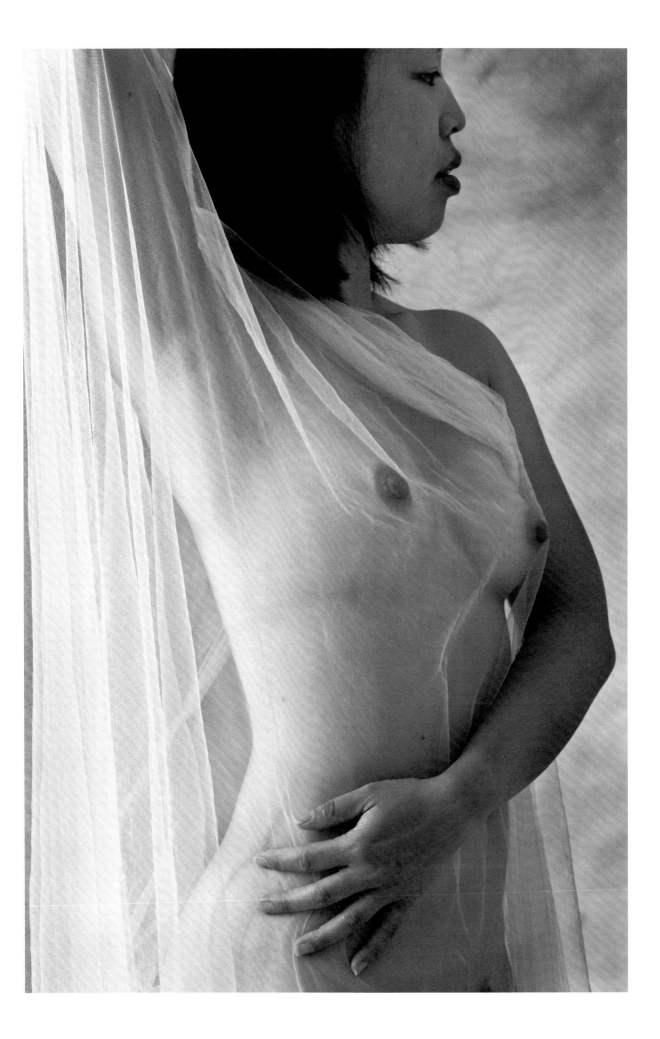

Brigitte, 35

As a personal fitness trainer, it's my job to inspire people into believing that the body we have or have always wanted is just a vision away. It's within our reach. But I must say I haven't always felt like this. It has taken me thirty-five years to accept my body; now it never ceases to amaze me. I have three beautiful children. After my twins were born, I noticed that there were a lot of people who seemed to have poor body images and low expectations of themselves.

I consider myself a role model of what good care, exercise, and nutrition can accomplish. Forgiveness is essential if you fall off the wagon; just make sure you get right back on. I'm also a strong believer that our thoughts can and will shape our lives. I like the saying, "There is always going to be someone smarter, richer, and more beautiful." I know it's human nature to compare oneself to others, but by becoming aware of this pitfall, we become more able to admire others.

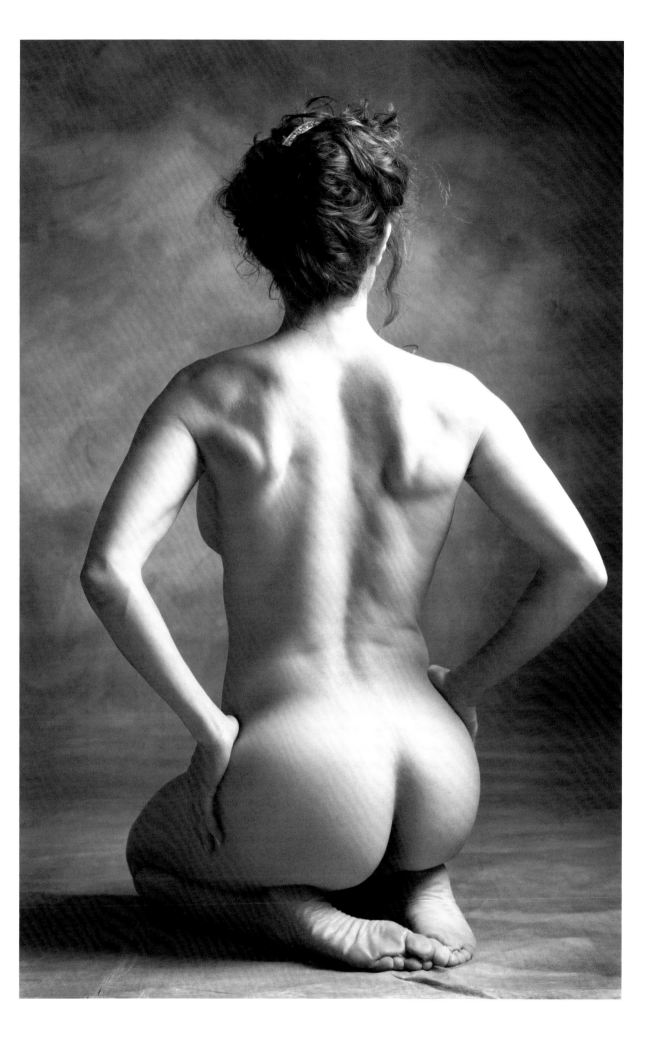

Jessica, 29

Anorexia has been helping me find myself. It's a strange thing to say but, now, after sixteen years, I know this to be true. She knocked on my door half my lifetime ago, when I was feeling so overwhelmed by being a young woman in the world. Being fat was the worst thing imaginable to me at the time, and I was terrified of it. I wanted to be the best I could be, to be good, to do the right thing. To not take up a lot of space. To hide. It was a control thing—if everything else was going poorly, I'd know that I was still okay if I could feel my sternum.

I never thought it was okay to love my body, and I couldn't say it was beautiful, because if even one person didn't agree, then it couldn't be true. It felt as though my body was owned by the outside world.

But I'm starting to develop a sense that I'm the one who owns my body, and I'm starting to think more in terms of how I feel and less about my waistline. I'm much more interested in being comfortable and not self-critical.

This journey to recovery continues. It's as though I'm reclaiming parts of myself every day. Slowly but surely, my soul is inhabiting much more of my body than anorexia.

"It's as though my body were owned
by the outside world."

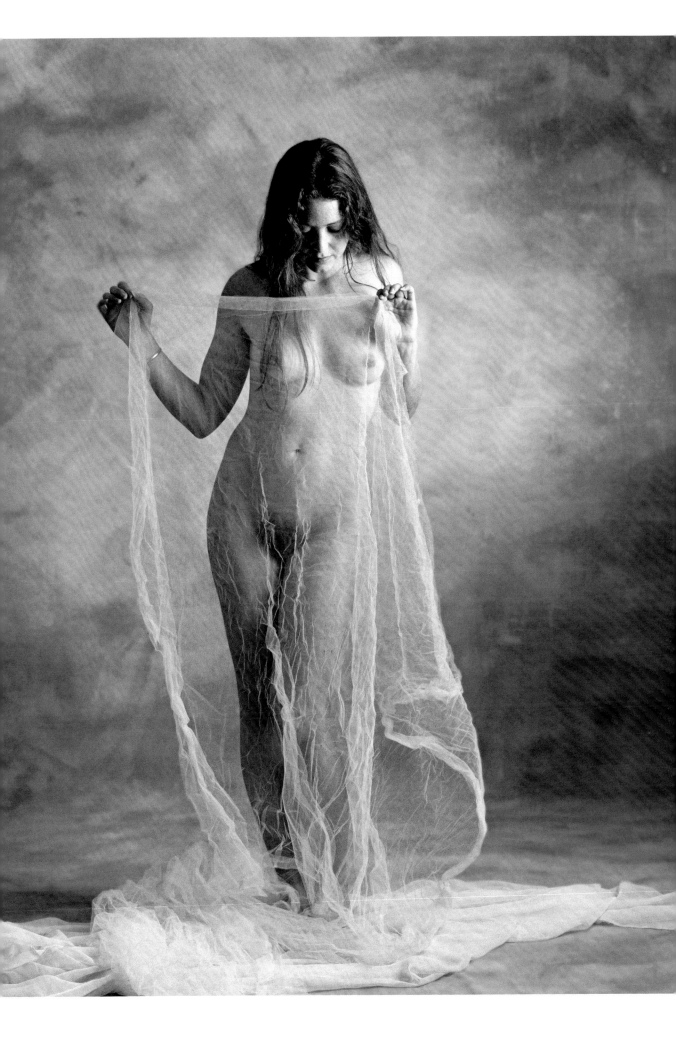

Rae Ellen, 59

In elementary school, people considered me skinny, but I didn't think much about it then. I was mainly concerned with wearing the right clothes and being "busty." In high school my concern was that I was flat-chested, and I hated that so much I wore padded bras.

At thirty-seven I weighed 142 pounds and decided I needed to join Weight Watchers because I was fat. (I'm five feet four inches tall.) Eating right and walking got me down to 125 pounds. I thought I looked good and I felt great about it. Slowly, however, the weight returned, mainly because I wasn't eating right or exercising. Each time I "got with the program" and lost a few pounds, it was more difficult and took longer to do—as if age was working against me. Four years ago I lost twenty pounds, gained it back over the next two years, and since a year ago have lost twenty-five pounds. I'm maintaining, but I want/need/plan to lose ten more. My size 12 clothes will then fit well, and I'll be happy with how my body looks. This is a realistic goal, and I think a fine size for a fifty-nine-year-old woman.

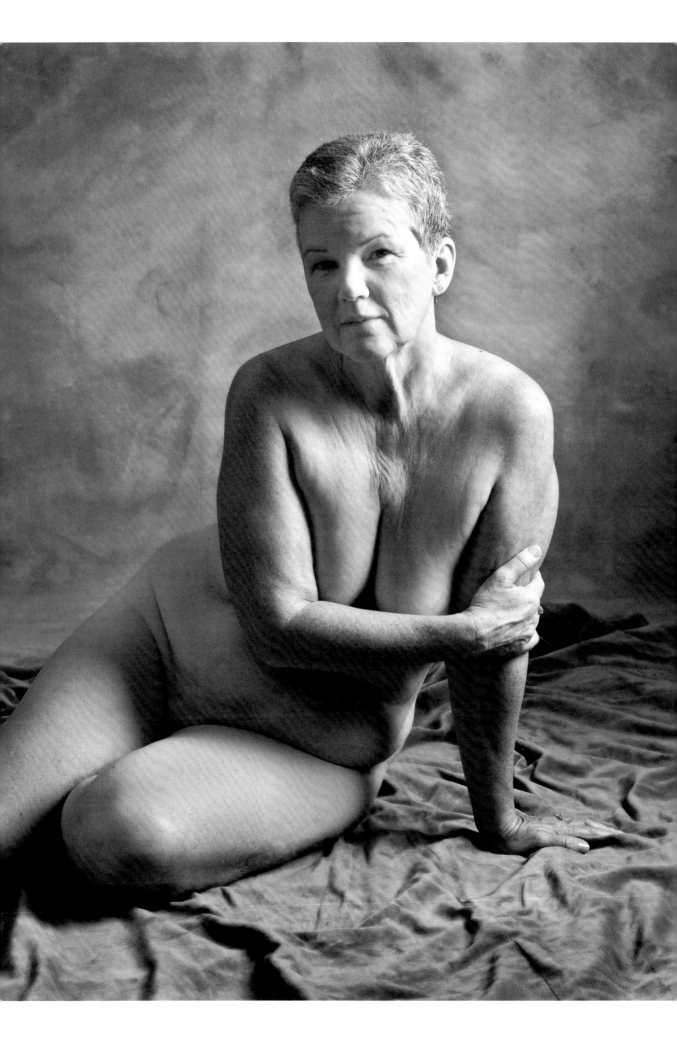

LaRae, 25

I don't like the fact that I gain so much weight, but it doesn't affect my day-to-day life. I'd like to lose weight, but I just can't imagine not having my butt or breasts. It kills me when smaller women say, "Oh, I'm so fat," and they're like size 4. When I tell them they look good and they start grabbing at their skin, it makes me sad—here I am, 250 pounds, and I love myself this way. When I was a child, my mother told me I was beautiful—and I believed her. I still do. I think I'm beautiful. Maybe I can also inspire women everywhere to love themselves, no matter their size, naked or clothed.

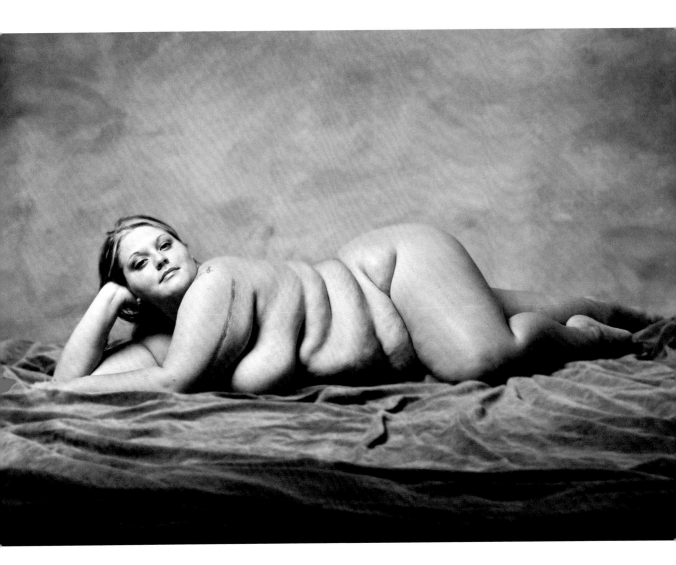

"It's all in what you think about yourself."

LARAE, 25

Jessica, 23

There are things about my body I've always accepted. I love my hands and eyes. But I would like to change my stomach and breasts.

When I was younger, I was too skinny and wished for a womanly body. Now I wish for the body I had as a kid. In general I think that we women think we're either too fat or too skinny—that we aren't what we wish we were.

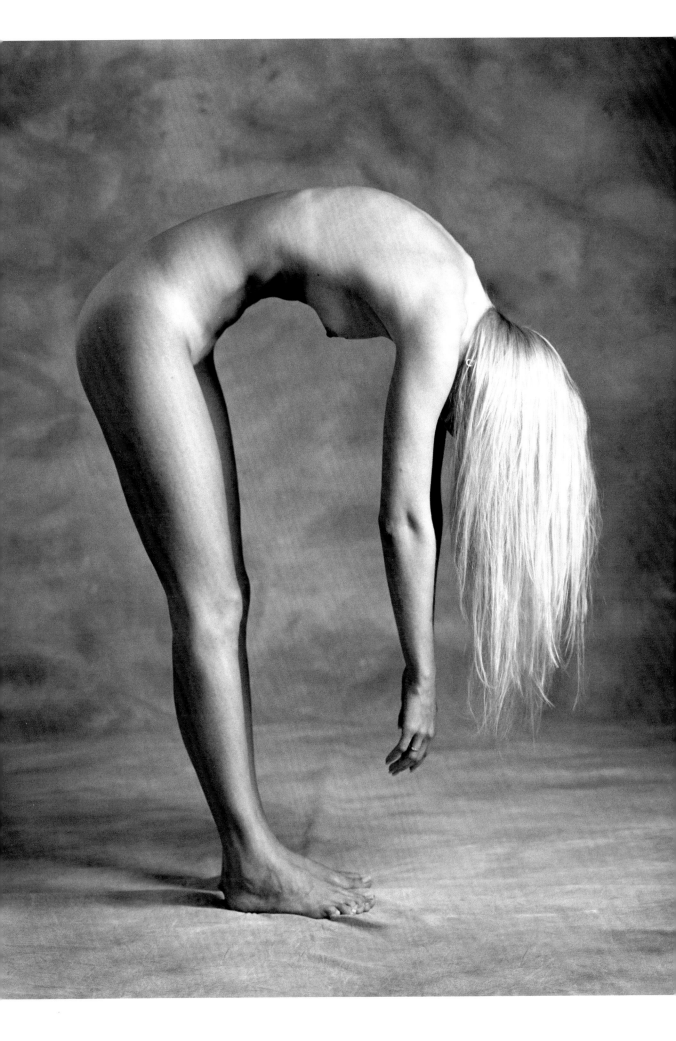

Barbara, 51

I'm comfortable in my body, which I think has a certain grace that's distinctively me. It doesn't seem right to admit that I am fifty-one years old; I feel fifty-one years *young*. I always thought that I was of two body shapes and longed for my lower body to slim down enough to match my upper body. After an eight-pound weight loss, I think I'm finally in proportion. Maintaining this weight makes me feel powerful and at ease in anything I choose to wear or not to wear.

What frustrates me is the wrinkling of the skin. I'm a sun worshipper, and I drink and smoke. I guess I'm letting my body down with that, but I support it by eating well, swimming, smothering myself in vanilla body lotion, and having great sex.

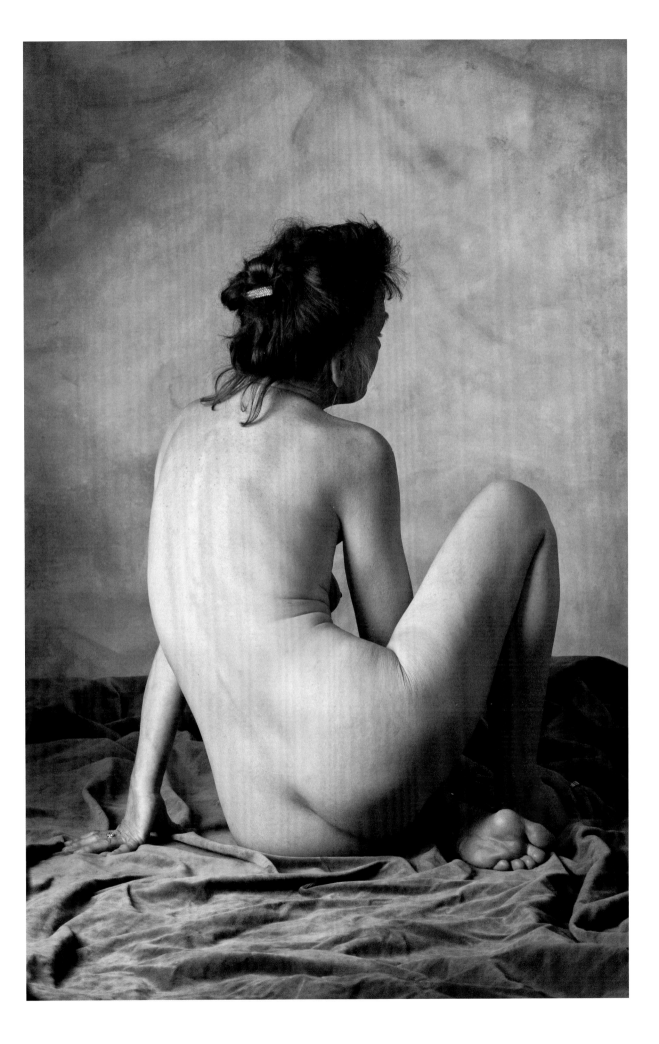

Jamie, 19

I'm happy that I've been gifted with a body that moves comfortably, willingly, and without pain. But I'm often frustrated by little things, and I feel insecure about parts of my body and the way that other people may be judging those parts: the sensitivity of my skin, my tendency to break out, the way I always feel bulky and overweight, the little bulge below my navel that just won't go away, the droopy cellulite on my backside, the high and big curve of my hips, the inflexibility of my hamstrings, the weakness of my ankles, the flatness of my feet.

My best friend is six feet tall, extremely thin, with tiny breasts, long legs, and pale skin—the media ideal, and the body I've always wanted. But she genuinely desires a voluptuous and curvy form. Most women I know want their bodies to be the opposite of what they are.

I don't, however, want to wish any of these problems away. I only want to change the parts of my body that will improve my overall health. The parts that I don't like, but can't alter naturally, I would never want to change. Perfection is a myth.

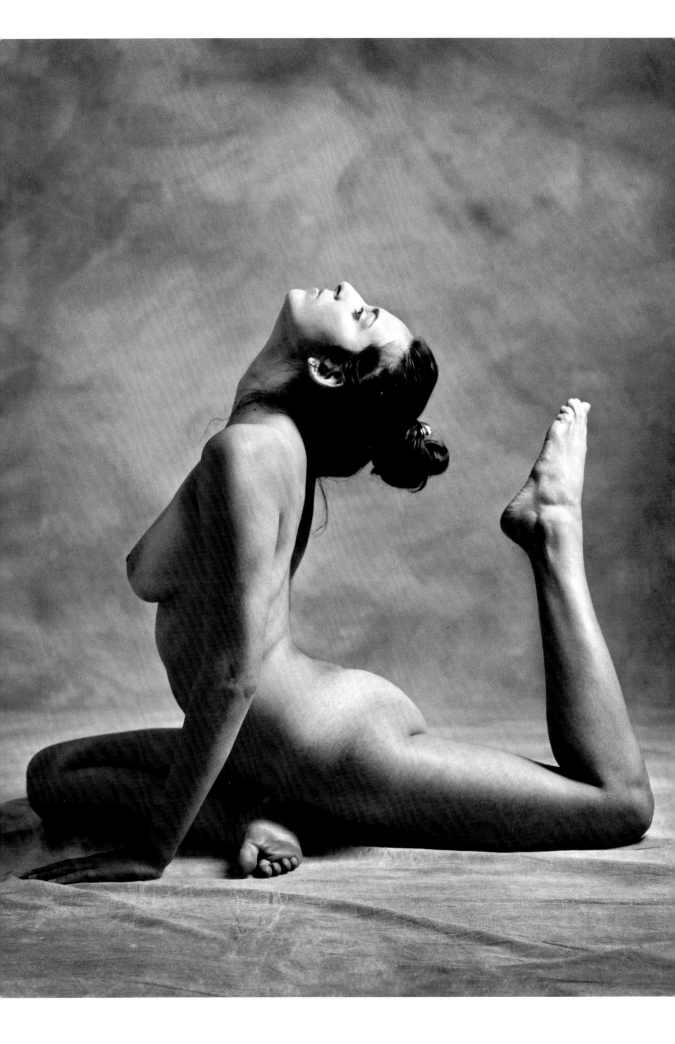

Rose, 44

I would love to change so many things about my body—especially my stomach. It seems to reflect how I feel emotionally. When it's big it means I'm sad. When it's small and flatter, I feel like I'm in control of my life. For years I wore nothing with a waistband and never looked at it. It was a forbidden zone. After years of overeating and fasts, my stomach was confused.

Getting older and giving birth changes your stomach. Being pregnant was one of the happiest times of my life. But when I had my son, it was difficult to reclaim my body. I still remember the deep sadness and sense of loss of control from not looking the way I thought I should.

After years of effort I feel like I've changed my attitude. Now my body shape isn't so life and death. Hindsight tells me life is short. I'm sad I spent my twenties and thirties worried about my weight and punishing myself. I don't know what the secret is to accepting and enjoying one's body, but I think it has to do with limits. Putting limits on food as well as on negative thoughts.

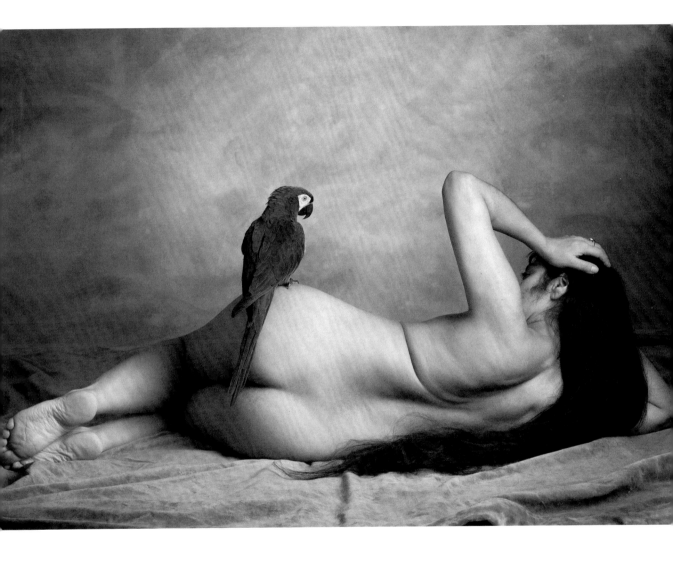

Sara, 32

Once, I was going to be a dancer. I was more serious about this dream than I have been about anything else in my life. I was twelve, and I wanted to dedicate my life to ballet. At thirteen, the walls of mirrors that had magnified my dreams seemed to warp. One shoulder crept relentlessly toward my ear, blurring the sleek, square lines of my shoulders. "Stand straight, Sara," barked my teacher. "You're slouching!"

I was not slouching. I remember in the doctor's office seeing my spine snaking down the black X-ray plate in a sickening double curve. I can still feel the hard plastic brace that cut into my thighs and my tender swelling breasts. I watched my back stiffen, my muscles atrophy, my dreams of dance die away.

If I wrote my body a love letter, it would speak of love betrayed. As bodies go, mine is not the one I would have chosen. It is frail, crooked, and easily bruised. It does not hide my past as easily as I would wish. Though I hold myself straight as an empress, my spine still curves, jutting through flesh to form an ivory question mark. But I still take good care of it. I take it interesting places, feed it French cuisine, play Chopin for it.

America is certainly plastered with images from "Planet Model," alien creatures with improbably high cheekbones and impossibly tiny waists. But don't blame the media. They're just selling what sells. American women complain that they're being objectified, and then rush out to buy stacks of glossy fashion magazines and watch bad movies featuring the beautiful but talentless starlet of the moment.

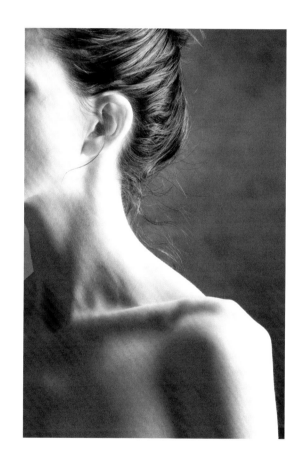

"If I wrote my body a love letter, it
would speak of love betrayed."

SARA, 32

(page 68)

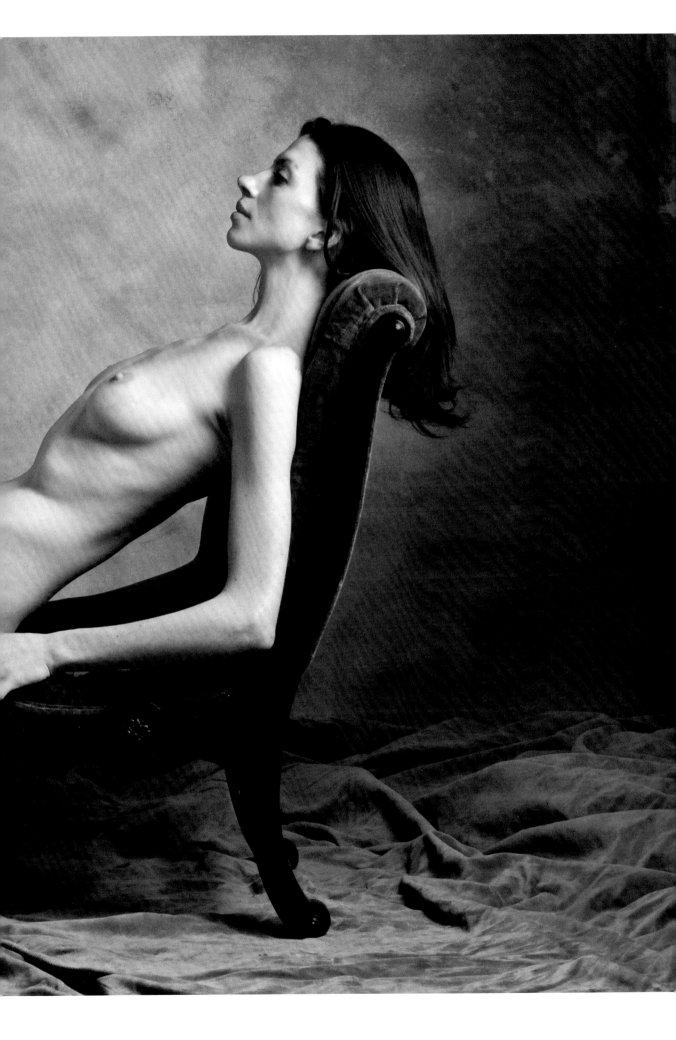

Loti, 38

I don't keep any hair. Some people see that as a beautiful thing, some look at it as disrespectful. When I look in the mirror, I'm happy with me whether I have hair or not. At one time I had hair, and a white friend would say, "Oh I wish my hair could do that" or "I wish I had skin like yours." And I say, "If you could have the hair—and the black that went along with it—would you take it all? Being black? Would you want everything that comes with it?"

Me? I'll take everything that comes with this ten times over. One of the things I love about my body is that it's brown. I've never had a problem with that, ever. I wouldn't trade it for anything. If I had a kid, boy or girl, I'd say, "Don't fall under the influence of what society tells you you should be." I don't think black families fall for that whole thing about judging yourself—I think that's more of a Eurocentric way of thinking. Being born black comes with something that empowers you.

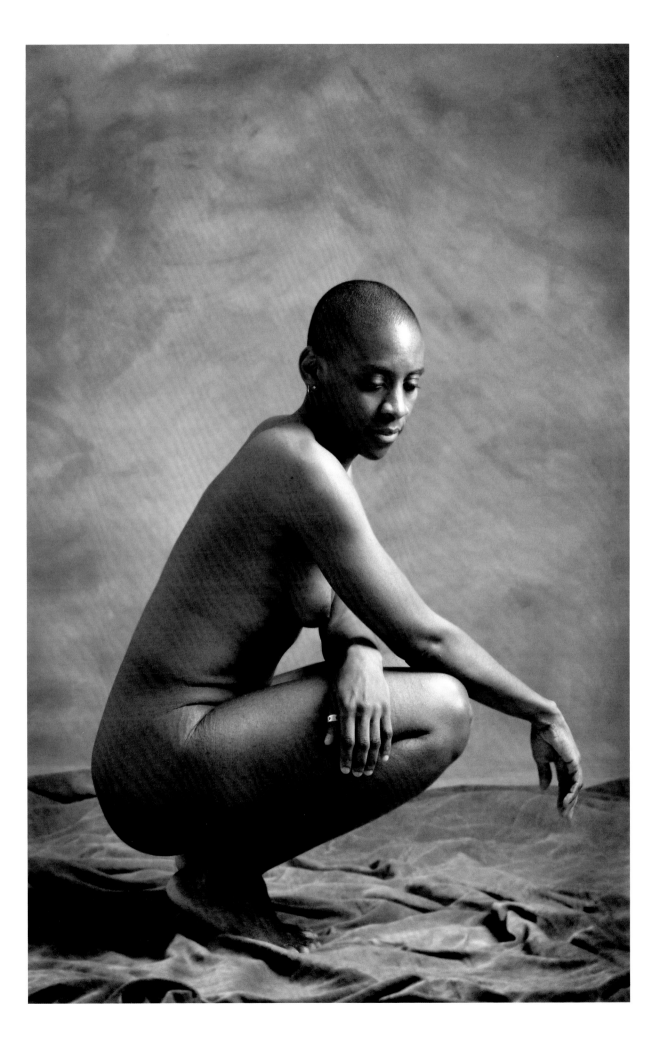

Cassandra, 34

Sometimes I wish I had slightly bigger breasts and a more slender fanny—
a victim of Barbie-conditioned culture, no doubt. I wish that I had wider
feet with high arches, not a bunion on one of them. Sometimes I wish I
had darker skin so as not to have to worry as much about sensitivity to
the sun.

Even so, I love my petite stature. I love the shape of my legs. I love
my strong and well-defined arms and back. I love my hands, and my skin
color. I love my belly button. And I love that my body is unique. I cherish
its ability to move in many different ways under a variety of circum-
stances; I value its innate ability to heal itself, given the opportunity. I
love that I have a fully functioning body. I love that I can give and receive
pleasure with my body. I love that my body dances.

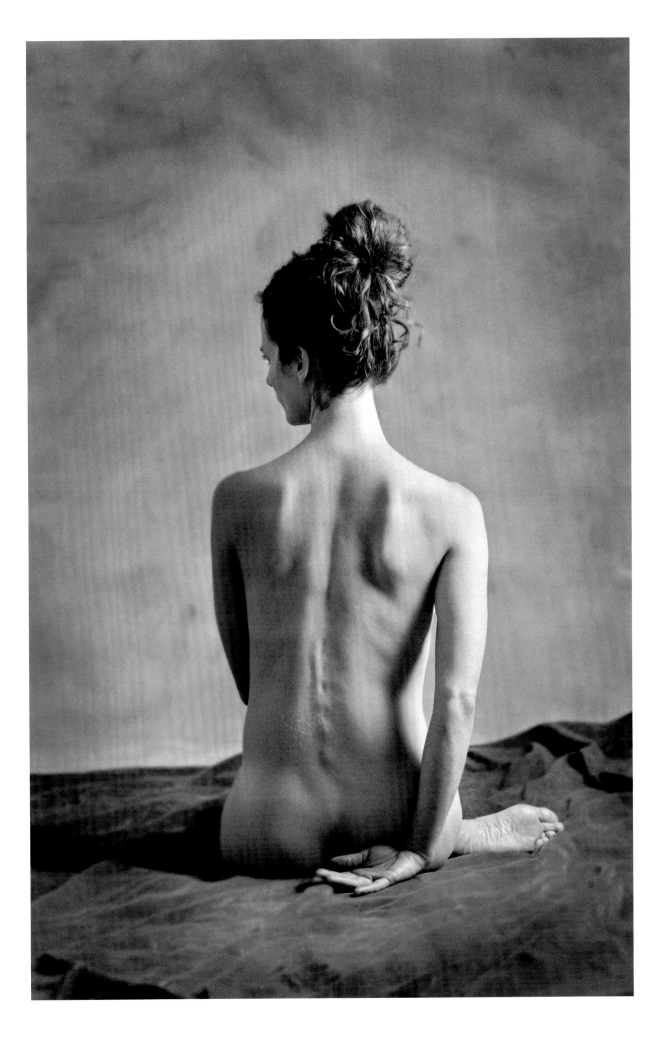

Gretchen, 42

I always thought that my body had good proportions. I like my broad shoulders, my height. I felt I was able-bodied and had strength. I loved my thick hair. I think I'm beautiful. It's true. I took much for granted.

Then I was diagnosed with breast cancer. I had a mastectomy. After the initial shock and emotion of the diagnosis and subsequent decisions, I quickly came to the conclusion that it was a small sacrifice to save my life. I didn't choose reconstructive surgery. It didn't seem right to have a foreign mass added to my body, to make me look and feel more "natural."

Now, when I look at myself in a mirror, I'm intrigued and interested. I have a nice smooth scar and actually have been complimented on it by doctors. When I turn to view my profile, I'm smooth and flat on one side, like a boy, and full-breasted, like any other woman, on the other. All of me is still here, just a little less. This isn't a deformity, it's just different. I'm so happy and grateful for this body I chose. I still see my stamina, my beautiful skin, my happy disposition, my youthful smile, my zest for living. The contortions that my mind and body have gone through with this fight are enough. I have learned to treat myself more kindly.

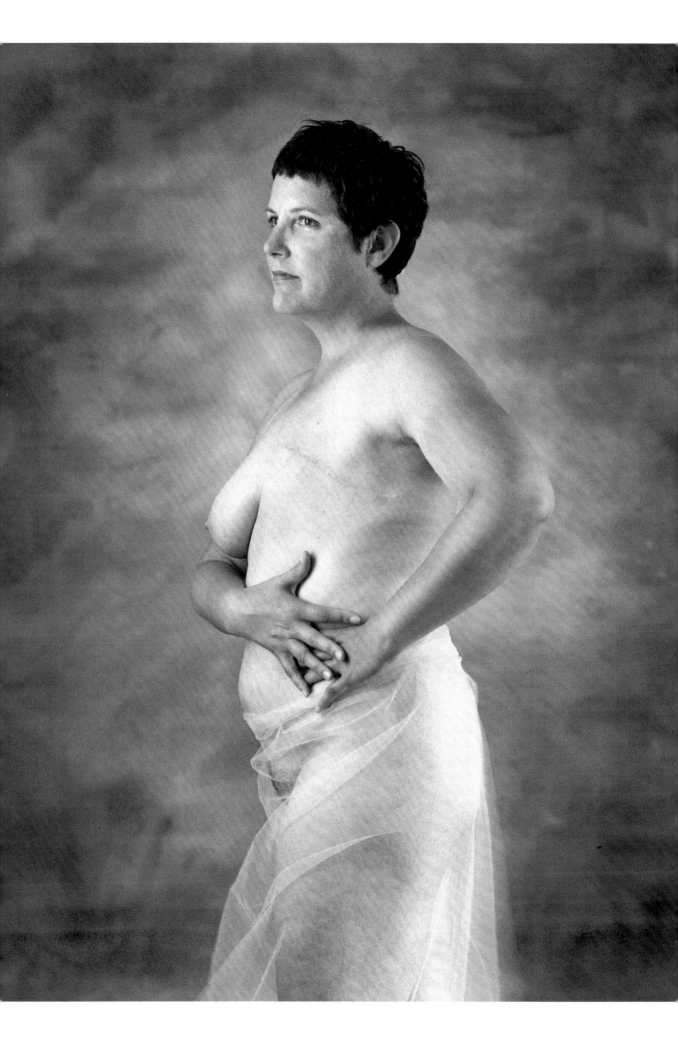

Anne, 50 · Lucy, 16

I believe the majority of women in this country vacillate between a guilty dissatisfaction with their bodies/appearance and a desire to reach the heights of beauty/desirability, outfitting themselves as twenty-something prostitutes. We're a culture that spends all this time talking about not eating, but then we drink double Frappuccinos with whipped cream and other oversugared beverages that don't do much to sustain a healthy mind or body.

My daughter and I are different in many ways, but I've taught her to be comfortable with nudity and to find her own style. If the only naked women you see are in glossy retouched magazine ads or in the movies, it would behoove you to visit a locker room or spa as part of your routine. There you'll see that bodies are actually hilarious. Don't take yours too seriously.

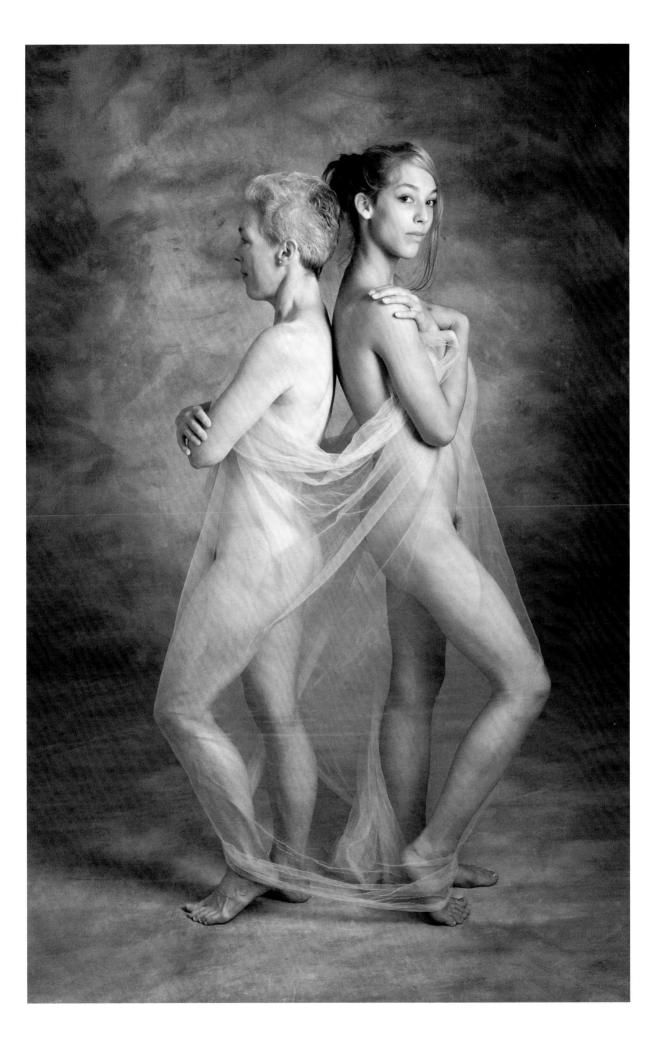

Jennifer, 33

We learn very early in life that beauty has a mysterious power. For years I thought I wanted others to find me beautiful, but what I really wanted all along was to find myself beautiful. What I didn't realize is that there isn't one kind of beauty. There isn't one person or group of people that possesses the monopoly on beauty. There isn't one face, body, hair, eye, or skin color that is the definition of beauty. Now I know there's an infinite amount of beauty—it can be found in the way a person moves, a well-sculpted arm, a graceful neck, lustrous hair, compassionate eyes, hardworking hands, a soothing voice, an enthusiastic heart. It's a powerful homecoming when we can hold our own gaze in the mirror, like what we see, and don't flick our eyes away from what is reflected back to us. I finally have found that.

For years I never gave my body much thought except for the things that I hated about it. Pregnancy pulled me back into my body, and for that I will always be grateful: for my full breasts, my soft belly marked with that mysterious *linea negra* running crookedly from my belly button in both directions. I even love the stretch mark that is a deep rose color, a crescent moon stemming from my belly button.

I don't know anyone who totally feels at home in her body except for my toddler daughter, who is too young to feel ashamed of anything. She likes to take off her clothes as soon as she comes home, and there she stands, plays, sits, climbs, and runs throughout the house, gloriously naked except for her diaper (and sometimes not even that). A sublime, beautiful body. She is totally unselfconscious. The idea of her turning against herself gives me pain. I want her to feel confident, to revel, to find herself beautiful in her own eyes.

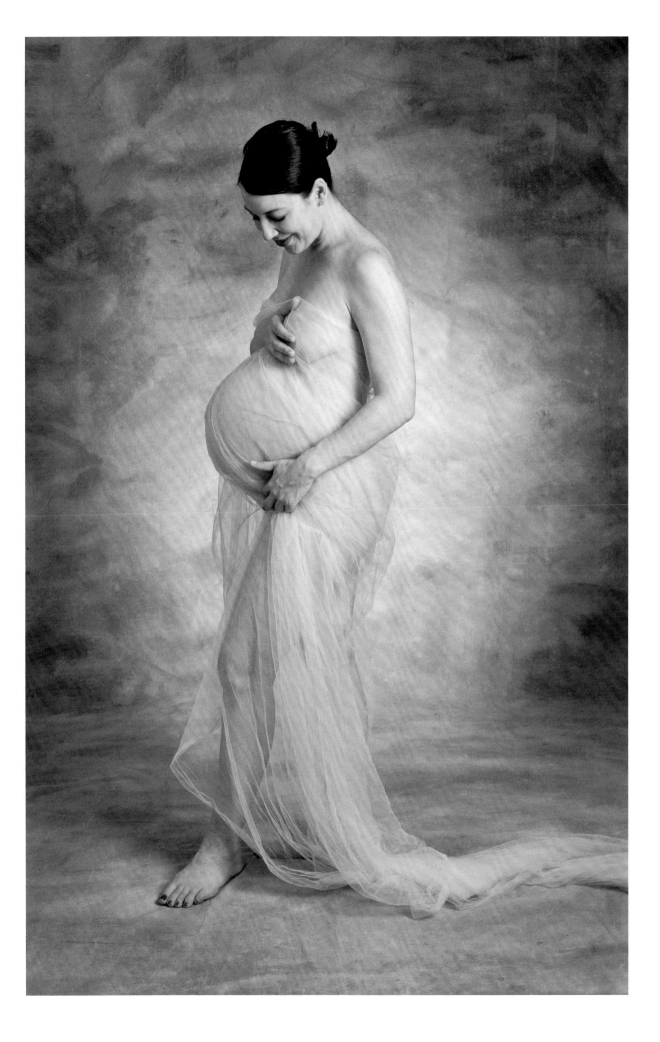

Dana, 30

I think magazines, and especially men's magazines, put pressure on us to be "perfect." I was looking at *Maxim* magazine recently and came upon a perfect example of this. On the contents page there was a picture of an amazing woman in a two-piece bathing suit. Her bottoms were tight, cut in on the sides of the hips, causing the skin around the bathing suit to indent slightly. This woman was extremely thin and still had rolls from her tight bikini bottoms. In the print media, no woman ever has this. I was feeling great, as if there was some hope that it was possible to show what a real—albeit skinny and beautiful—woman might actually look like. Then I turned to the article, and there was the same photo, with the rolls digitally removed.

And there was the famous article in *More* magazine about Jamie Lee Curtis that showed the public what the magazines really do to celebrities. In the "before" photo she was wearing a sports bra and some shorts, just a normal-looking woman. The photo on the opposite page showed how she had been retouched to make her look younger and trimmer. All this digital retouching makes us feel that when we put on a bathing suit we're too fat and that curves aren't normal.

The media definitely influences how I feel about myself. It makes me work out more. That's good in a sense, but I'd rather my motives be for reasons of health and strength.

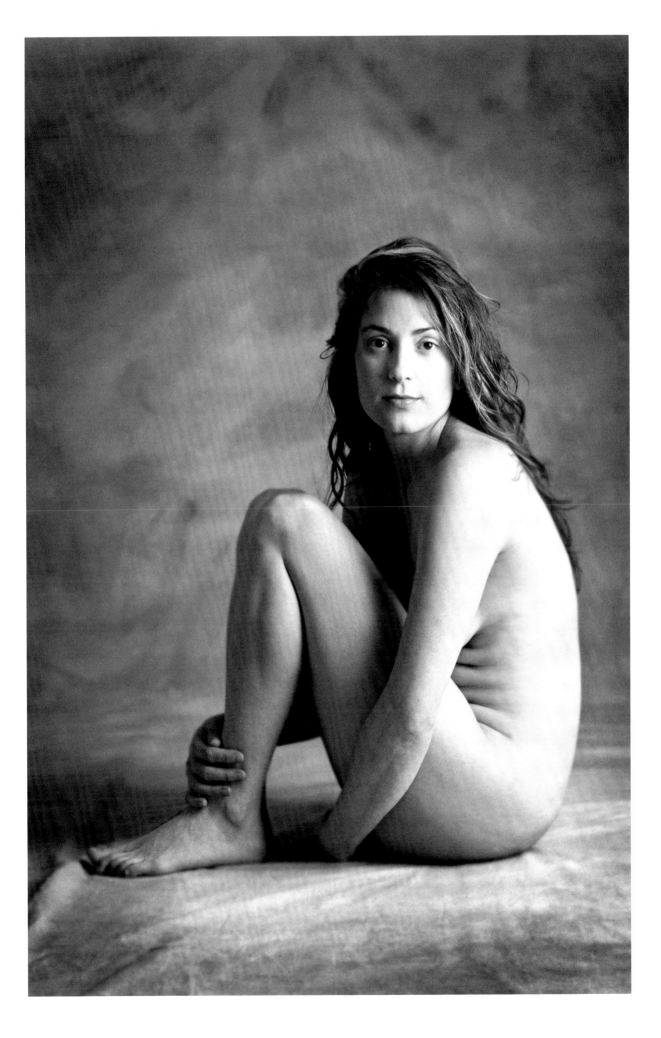

Sarah, 29

My birth was traumatic to say the least—all my intestines were on the outside of my stomach. I had a nine-hour surgery and was in an isolation chamber for five months. The doctors said that if I survived childhood, I'd probably be about four feet ten inches, very sickly, and not very active. They were wrong. I'm one of the most athletic people I know.

I wasn't able to be held by anyone for those first few months, so my mother never got to bond with me. Growing up, I didn't like being held or touched. Around age six or seven, I became aware of my scar as something ugly. The most difficult part was trying to hide it from people. When I was six, I was taking swimming lessons at school. Somehow I didn't conceal myself very well. A little girl screamed in the dressing room, "Oh, my God, what is that?" I really started feeling ashamed when I got interested in boys. I didn't date in high school because I didn't want anyone to know. I was considered a pretty girl on the outside, but I was so worried that if people found out about the scar, they wouldn't see me as pretty anymore.

As I got older it got much easier to say, "This is what I have." The boyfriends I have had have been very loving. My scar has helped me to choose men who are kind and good.

But I never feel sexy. Even to this day, I get angry at the fact that this is something I don't have any control over. Maybe that's why I work so hard on keeping in shape. I've learned discipline and a deep appreciation for working out, strength, muscle, and a powerful body. I've learned I can change the things that I have control over and use them to my advantage.

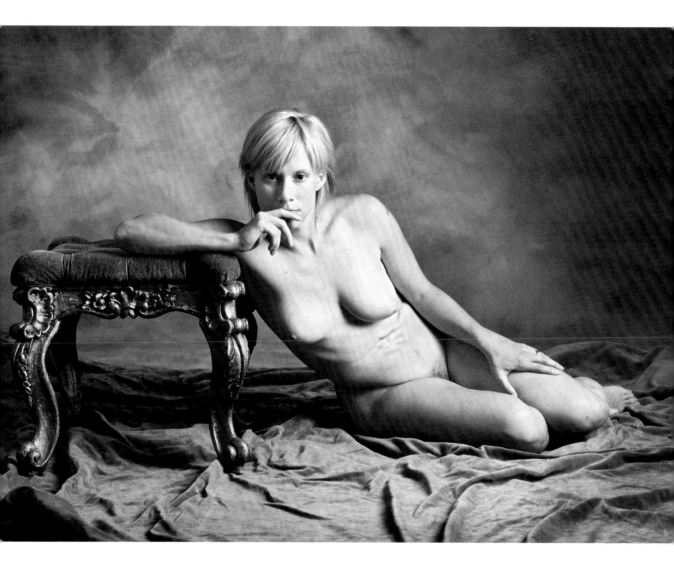

"I wish I were one of those women who
love their body no matter what shape it is."

SARAH, 29

Susan, 48

I used to pretend that the blossoming size of my silhouette in the downtown store windows didn't matter. Before leaving the house I'd look in the mirror, but only to examine the clothes—a quick check for cat hair rather than confronting the face and body I could no longer recognize as my own.

Then last spring, an old friend came to visit. In honor of her upcoming fiftieth birthday, my friend had dropped fifty pounds. The night she arrived, I watched her carefully choose a crispy chicken dish off the menu at my favorite Thai restaurant. In the early hours of the morning, she invited me to join her on her daily walk. I got inspired. What would happen if I tried to lose the weight I'd gained over the past seven years? What if I once again recognized myself in the mirror?

As a feminist, it seemed to my mind impolitic to diet—"fat is a feminist issue" and all that. And yet, the idea seeped into my consciousness: What could happen if I set my mind on making my body look healthier?

Eleven months later, I find that the shape and contours of my shoulders, breasts, and hips have become more familiar. Certainly stronger, more like the form I remember living in a decade ago. Losing thirty-seven pounds is magical. I honestly believed that fat cells were here to stay, the laws of diet and exercise didn't hold true for me.

Every hour of every day I work to keep this new body in line. Every coffee shop teases me with sculptures of whipped cream and gargantuan cookies. When I finish lunch, I start wondering about dinner. Why do I need to watch what I put into my body with such vigilance? Why does my body betray me if I indulge in a bit of blue cheese? It frustrates me that this is a lifetime challenge: the tongue versus the chin, the taste buds versus the circumference of my thighs.

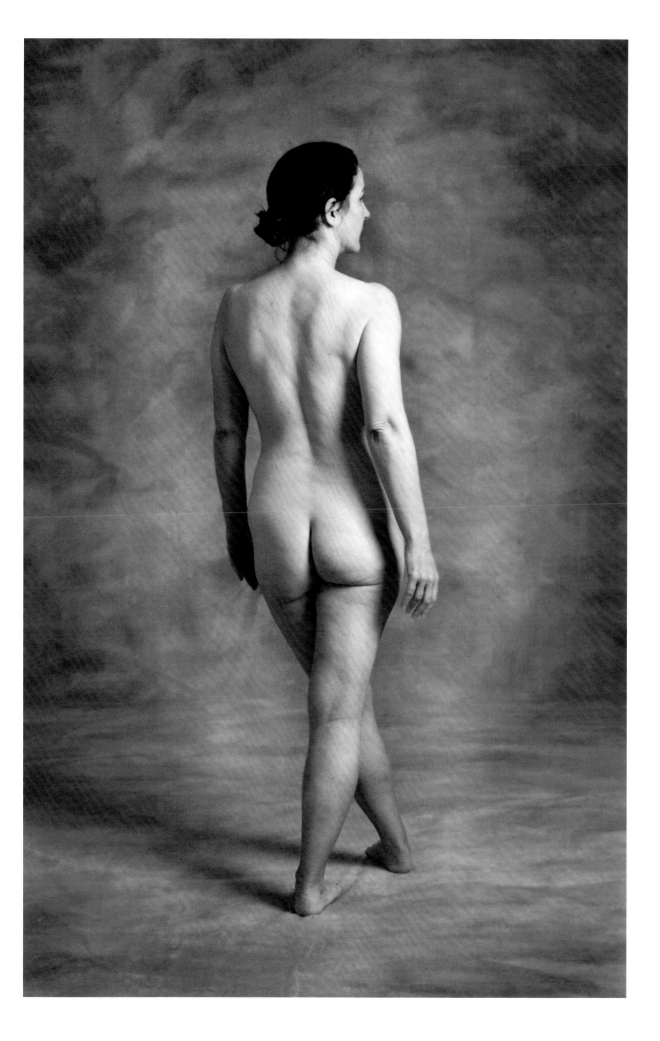

Gerrie, 29

I grew up in Asia, where women were either petite or tall and willowy. Beauty and normality were somewhat defined by the notion that you aren't fat—which means you should weigh 100 pounds or less. My parents instilled in me the idea that I should be concerned about staying healthy, regardless of body size, but I always hated the fact that I was bigger than the average Asian. I loathed the shape of my body because it was nowhere near what "normal" was. I became bulimic because I felt the desperate need to be skinnier to fit in.

Then I moved to the States to go to college. Here I felt that people were not so focused on how they looked or so fashion-minded. I didn't feel that I had to keep up as I did in Malaysia. I stopped forcing my body to conform to what I thought it should look like and started to take better care of it. I stopped the bulimia when I realized that life is not all about trying to mold yourself into what society perceives you "should" be. Striving for the perfect body is not worth destroying your health.

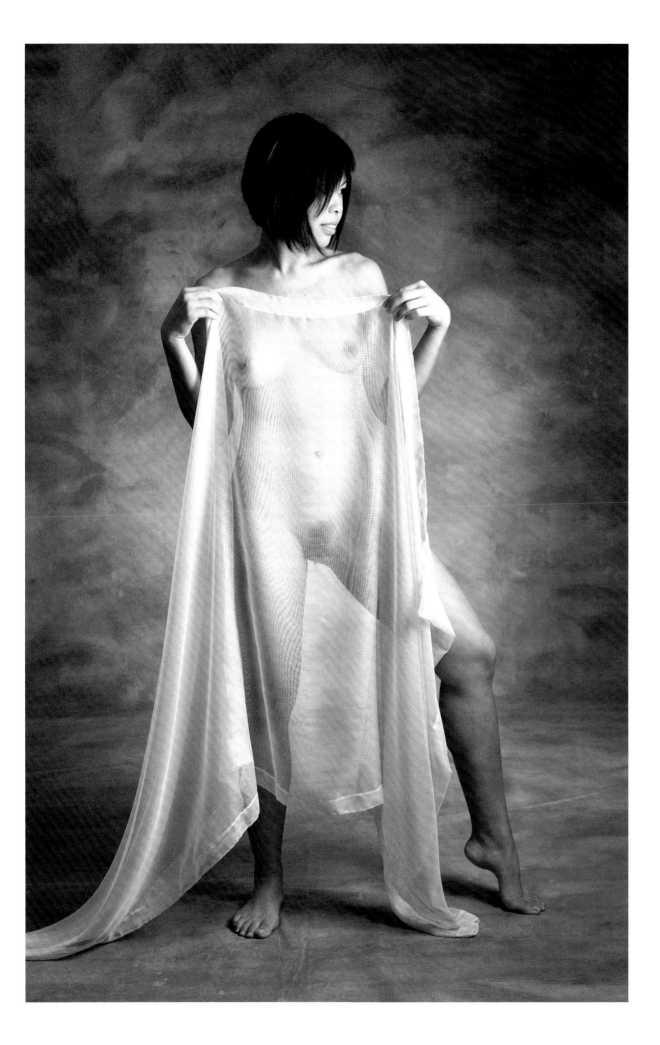

Angela, 35

Without a positive male influence in childhood, I was ill prepared for the sudden, powerful, and constant attention of men and boys when I developed curves at eleven. I used flirtation as a form of currency to gain attention and get my way. Eventually, to my disgust, I realized I was the commodity, a pawn in the chess game of the sexes, swept up in the ever-changing and confusing role of what a woman was to be: vixen, virgin, brain, dumb blond, independent, or submissive. During that time I gained considerable weight. Throughout my twenties I managed to distance myself from my body as if it were something beyond me, a means to get me from place to place.

I am finally comfortable in my own skin, even though being an overweight woman in the United States still carries a tremendous stigma. In addition to health fears, we face the social stigma that we are somehow "less than" and lazy. Granted, weight is typically an outward revelation of an inward struggle, but what I see in myself and my overweight friends is a surprising exuberance for life. I can't walk down the street without trying to make eye contact or engage people. I'm quite active outdoors, and I have boundless energy for things I'm passionate about, such as working with the elderly and coming up with new and innovative programs for them—gardening, camping, hiking.

Today I continue to develop through spiritual growth and self-reflection. I also try to take classes a couple of times a year that are a little out of my comfort zone—things like cardio-strip aerobics, belly dancing, snowshoeing. I like to keep my body fit enough to do the things I love.

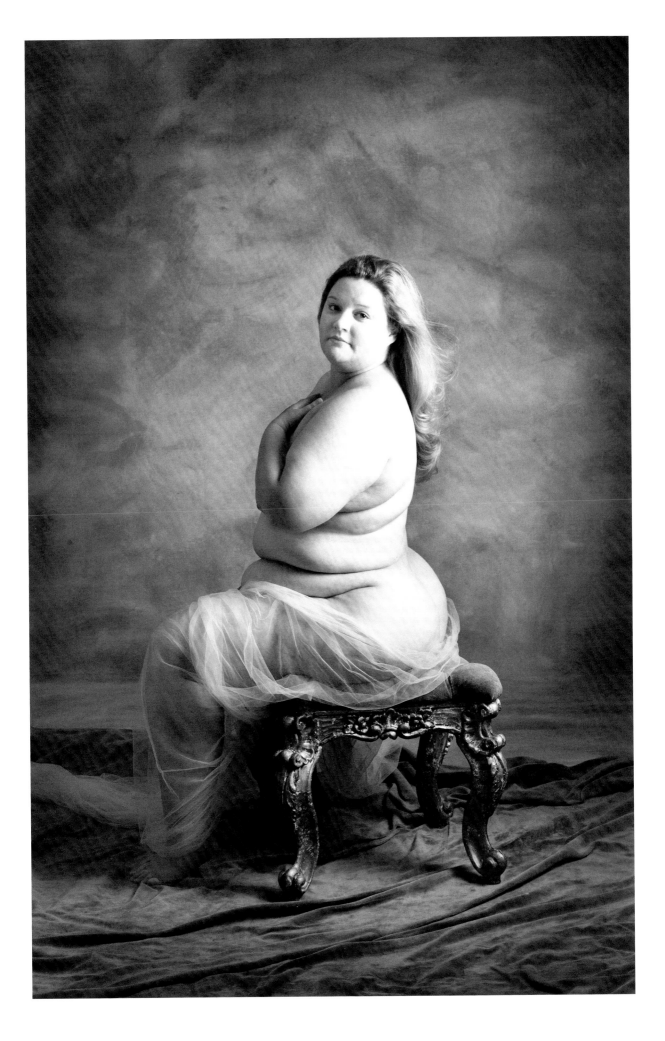

Megan, 34

For the first part of my life, I was a relentless gymnast, in love with the elasticity of my body. It was a sensual, physical experience—feeling my spine curve and flex, my back arch and my bones stretch taut.

But when your world is out of balance, your body speaks. I learned this at fourteen, when some cosmic accident caused my spine to exhibit an abnormally speedy curvature and start to crush me like a kind of internal boa constrictor. I began to regularly fall off the four-inch beam that was my existence. It took a metal rod, some serious surgery, and the return of the two and a half inches that I had temporarily lost to scoliosis to provide a new sense of balance. And it has taken me many years to understand, as if I were slowly climbing a ladder to the moon, the fragility and strength that you have to exercise when one part of your body is completely inflexible. Having a will of iron is a welcome addition when you have seven pounds and fourteen inches of steel hooked to your spine like a frangible sapling. I've invented my life around my body.

When you look at me, there's no way to tell that I didn't become the girl on the flying trapeze. I'll never be an old woman hunched over as she walks, but I should have been. At thirty-four, I am at the age that if I hadn't been operated on I would have the appearance of a crone. Instead, as a dancer, I have the appearance of uprightness and strength, and I walk a walk of pure authority dictated by solid steel. I also have the knowledge of my alter image, which cannot ever be straightened. It grows alongside me, curving into itself like a spiral with no end, looking out at the world through my eyes. To integrate the courage of the one with the knowledge of the other is a goal that I work every day to achieve.

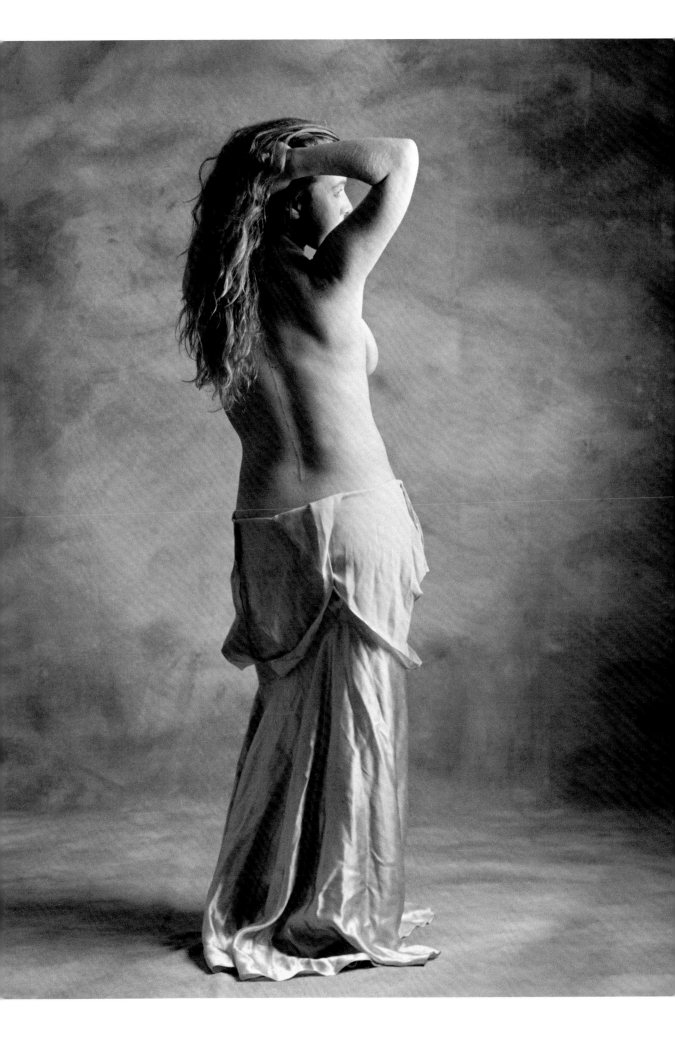

Candace, 52

I loathe myself. I'm a survivor of incest. When you're a child and are taken advantage of in that way, you end up hating yourself, blaming yourself for what happened, even though you couldn't do otherwise. Any abused child would understand. There's the intellectual part of me that says it wasn't my fault, but there's still this part of me that says, "You should have said no." I think every decision I've made in my life has been permeated by this until recently.

Because of my height and my slender body, people think I'm another attractive woman who owns the world. But I'm really this icky little girl who allowed this to happen. You don't get over it. It colors your whole life.

Sometimes I can appreciate my physical and emotional strength. I can appreciate my body when it's perfect—the cut of muscle down my stomach, the definition of my thigh, the way my gold chain hangs on my waist. But I struggle with who I am inside.

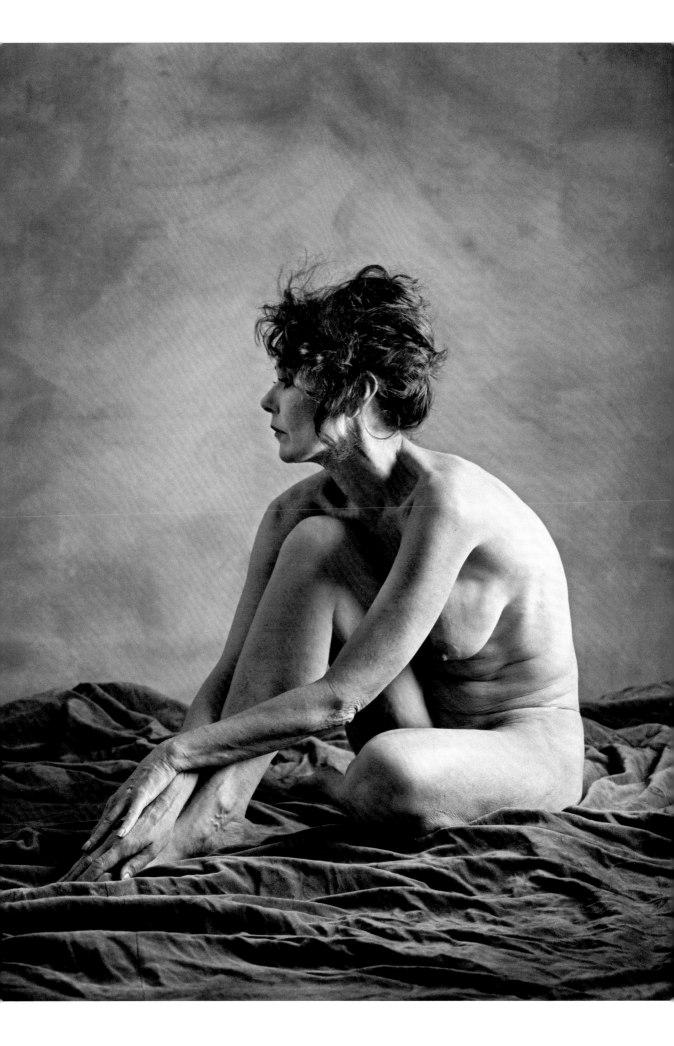

Katie, 37

I grew up with men who saw women as sexual objects, which is why I always wore baggy sweatshirts. It's only recently that I can get dressed up, go out, feel sexy, and enjoy attention from my peers.

My daughter is seven, and she's already getting comments about her body, on how pretty she is, tall and blond. I feel enraged that so much attention is placed on her looks. I don't think I'd mind if they commented on how strong she is. I feel like a mother bear around her—very protective. I just want to shelter her from our culture's obsession with women as objects to view. I'm teaching her about meditation, about the strength of her own body. I hope she can get self-confidence from that and not worry about what other people say.

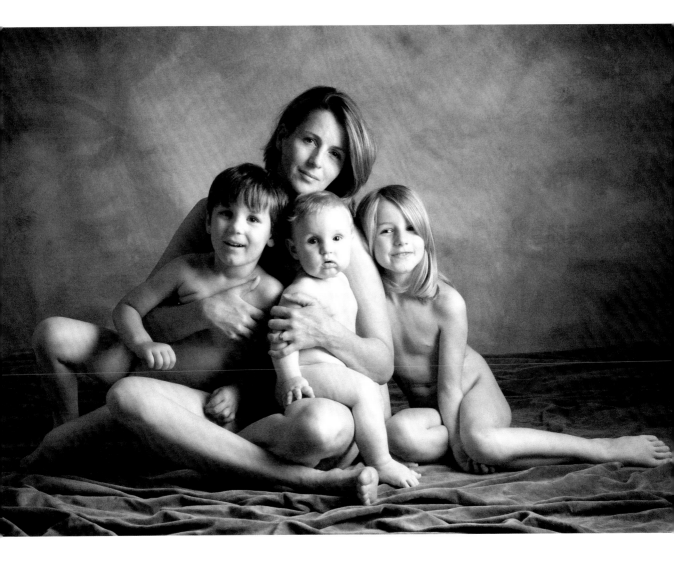

Stephanie, 41

My body looks more like my mother's every day. Does everyone say that? Regular workouts don't seem to budge the steady coating of fat. I'd like to lose a lot of weight and gain a lot of muscle. I do triathlons; I would like to look like a triathlete. If you asked me ten years ago—when I was at least fifty pounds lighter—what I like about my body, I would have said absolutely nothing. Now I could care less what I look like when I'm competing.

What people don't realize when they look at me is that I am a lawyer and have two advanced degrees and am working on my third. People are always shocked. I'm not sure if I look dumb or if they just don't expect this from a black woman.

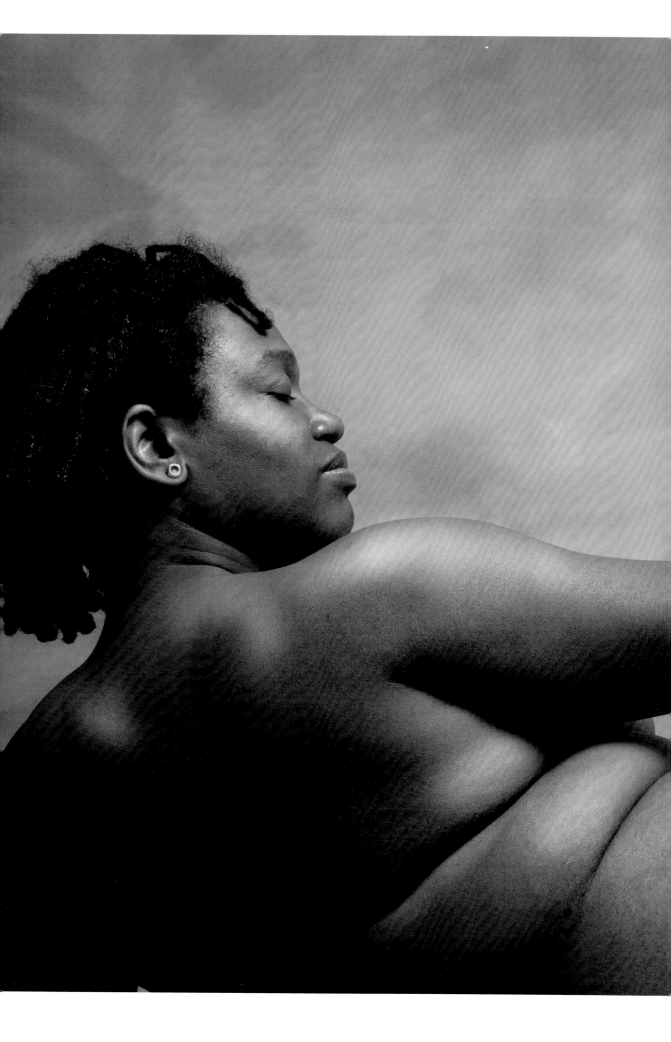

"My body looks more like my mother's
every day. Does everyone say that?"

STEPHANIE, 41

(page 98)

Joann, 31

I grew up in a culture where part of self-worth is based on your looks. I recall going to gatherings of family and friends where the focal point of the conversation was about weight—who got fat, who's getting fat, and who they think will get fat next. I never wanted to be the one they talked about. I made sure that I was at my best shape at every get-together. Once, I caught them talking about my three younger siblings, all of whom have also struggled with weight and body image. One of my sisters was in tears. As the oldest, I acted like a mama hen protecting her chicks: "It doesn't help them with their self-esteem when you talk about their weight like that," I said. Since then, the body issue hasn't been discussed. Not around me, at least.

Though my body's not perfect, I'm now at peace with it. What are my favorite parts? My brain—a well-oiled machine that absorbs wisdom and experiences and never seems to take a break; my legs and feet that take me miles and miles to my destination (I walk everywhere!); my teeth, which reflect part of my vanity; my smile that reveals when I'm happy; but most of all, my mother's eyes and hands and my father's nose and lips, which tell me I'm theirs when I look in the mirror.

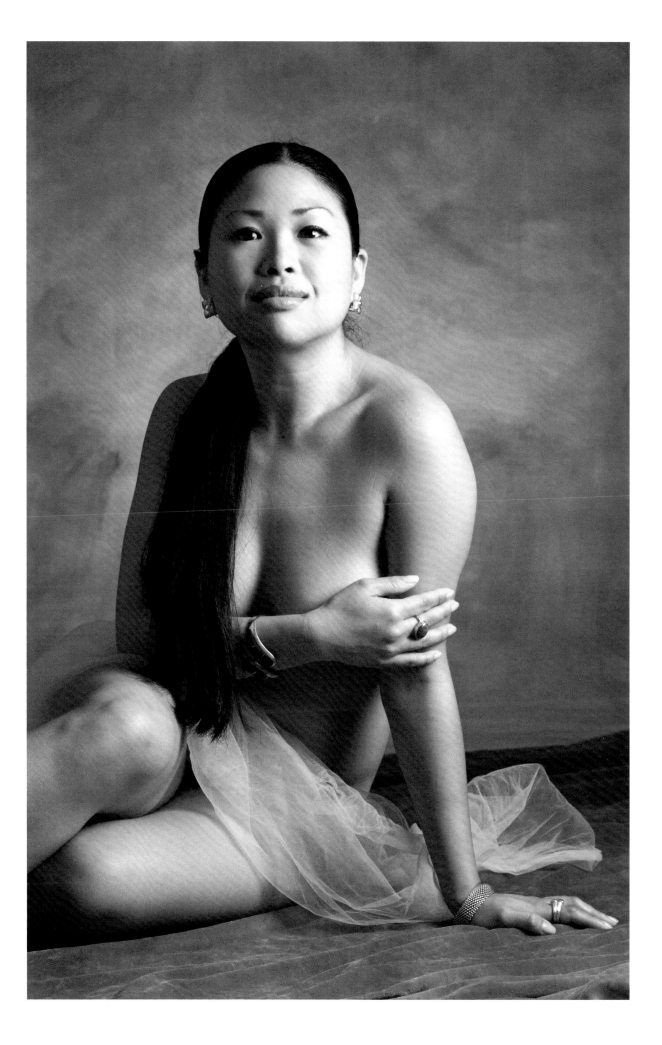

Carrie Kay, 45

I got pregnant when I was sixteen. I didn't like my body before I got pregnant. I thought I looked different than the other girls. I had small breasts, a short waist, and wide hips. My peers were wearing halter tops and hip-hugger jeans. I thought everyone was cuter and thinner than I was. After I had my daughter my stomach became a mass of stretch marks. My young skin hung embarrassingly loose and unattractive.

Over the years I have had lovers tell me they loved my belly because it is a part of me and because it symbolizes motherhood and nature. I didn't believe them. I remember wearing a tight, itchy girdle under a summer party dress in one-hundred-degree heat.

I was a young mom so I am a young grandma. People are usually surprised to find out I have kids old enough to have children and I like the compliments I get about looking too young to be a grandma.

When I was twenty-nine I came out. I was married to a man and had three kids. We lived in a small conservative Dutch town. We divorced, and I moved to a bigger Midwestern city. I had no idea what to do. I tried to find my place in the lesbian community.

I had screwed-up ideas about what I should look like. I cut my hair, got tattoos, and began wearing grungy cutoffs with black combat boots. I still didn't feel like I fit in. I thought I needed to look like a boy, but my body betrayed me by being too curvy. My first female lover told me no other woman would ever want me because I had children. Today, I don't compare myself to other women. I love my tattoos but wish I didn't have them. I don't feel the need to draw attention to myself in that manner anymore, and sometimes I'm even a little embarrassed by them. They are so permanent.

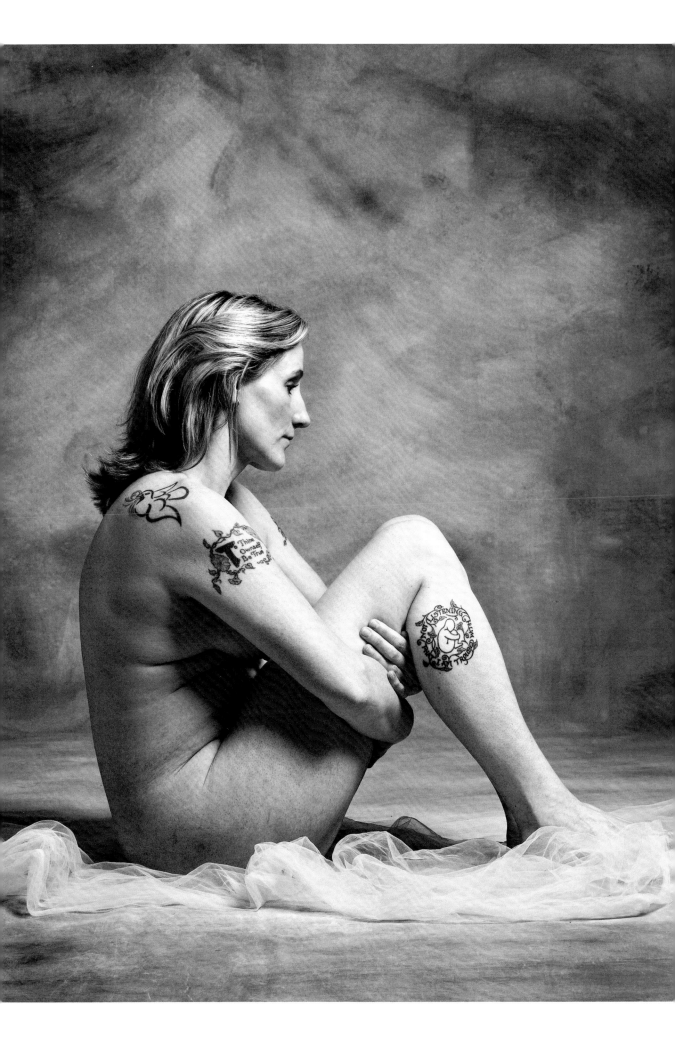

June, 40

I don't like my body at all but that doesn't mean I don't love myself. I actually think I'm a pretty great person.

I use food to comfort me, to numb me, to make me feel all warm and fuzzy inside. I don't want to be this size but I feel so weak and tired and keep putting off eating healthy and exercising. And my body is not springing back now when I start to lose weight. I'm forty and I'm starting to sag and ache and feel bloaty and very tired. Ugh. The more time that goes by the harder it is to get on the right track. I don't want to be thin, I just want to be healthy and feel energetic and do everything I was meant to do.

I was always an average-size child, but I developed faster than any of the other girls and I got a lot of unwanted attention from men, which terrified me. So all through junior high and high school I never had a boyfriend and I never let anyone come that close to me. I also began to gain weight at this time. I was truly blessed that I was never teased, but I wish I had had someone to tell me that I was gorgeous no matter what size I was and that I looked fabulous.

Now that I'm older, it is amazing the confidence that I have, the friends that I have, the love that I feel for people and myself. I don't let things bother me, and I don't care what people think about me anymore. If I lose weight, it's only for me and no one else. I just love being me.

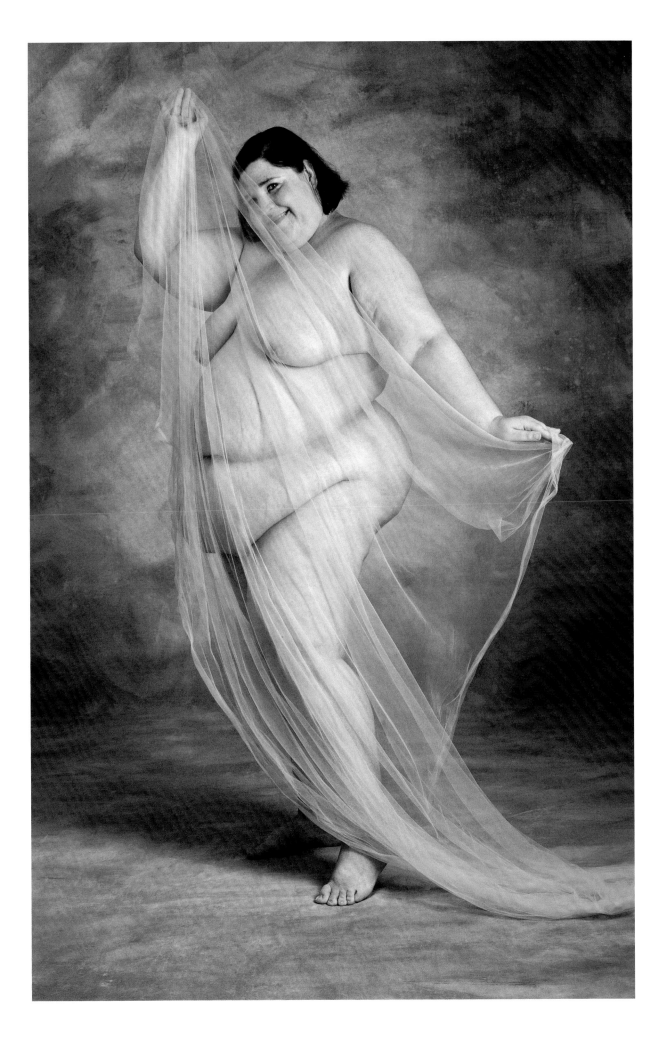

Ellen, 52

When I turned fifty, it hit me that I wouldn't have another child. Starting menopause, my body wouldn't give me that opportunity. Where would I put my energy? I had to pull myself up—get back to my work, start piano lessons, yoga. I started to feel different. I grew my hair long and quit blow-drying it. People would stare me down every single day. I've just learned to stand up and smile.

I've started looking at older women to see how they walk and carry themselves. I try to find things that fill me, make me stop and take a breath. Whenever I start feeling down, I go to yoga. When I start looking in the mirror and see the wrinkles I say, hey, go to a museum, read a book.

In the last two years I've started noticing changes in my body. It's not as easy to keep weight where I would like to keep it, and I have wrinkles that weren't there before. I wonder why I don't remember what I looked like before. My aesthetician tells me about the people she has worked on who have had plastic surgery, how their skin is so fragile. She said that if you stand straight and carry yourself well, it makes an impression on people, no matter how much money you have spent on your face. I think if people are graceful and have some peace within them, then they are beautiful. I was at a restaurant when this very thin woman walked in—pumped-up muscles, bleached hair, skin-tight red dress. She ran her hands over her stomach. She was so self-conscious. There was no grace; she needed everyone to know she was there.

It has taken me almost half my life to learn to appreciate and accept myself as an attractive woman. That also means I have had to learn to accept my attractiveness in a sexual way. And here I am, fifty-two and just now finding out that there is fun in being sexy!

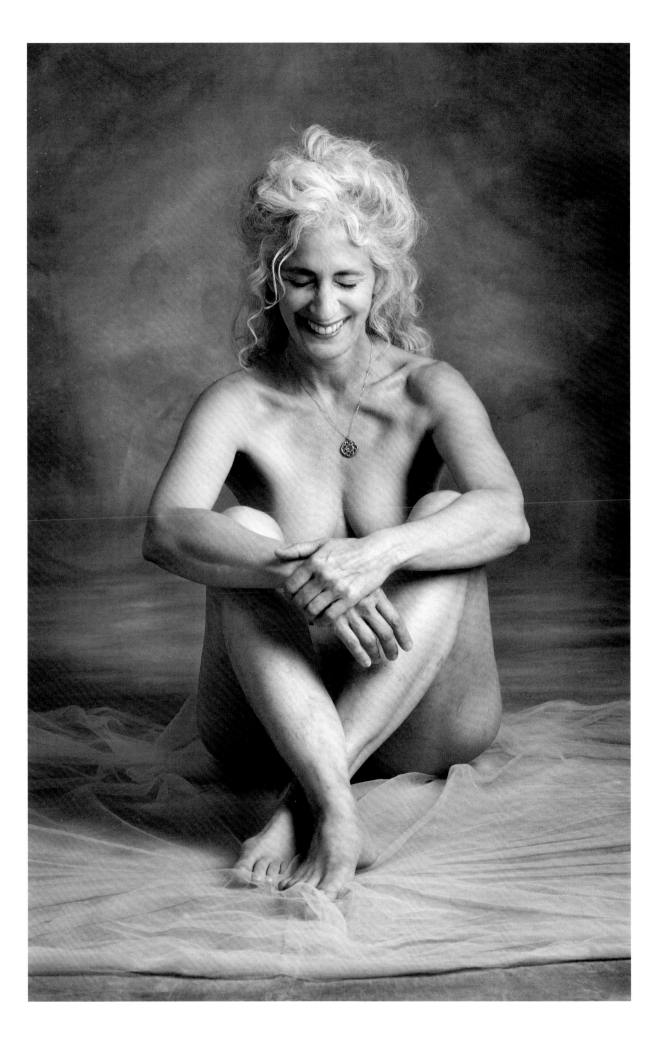

Alice, 95

At my age, pain frustrates me. The curvature of the spine appeared at midlife; that it cannot be reversed is a disappointment. But I'm too busy to dwell on problems. This is the body I was given, and it has served me well. I never thought about loving it, but I have accepted it.

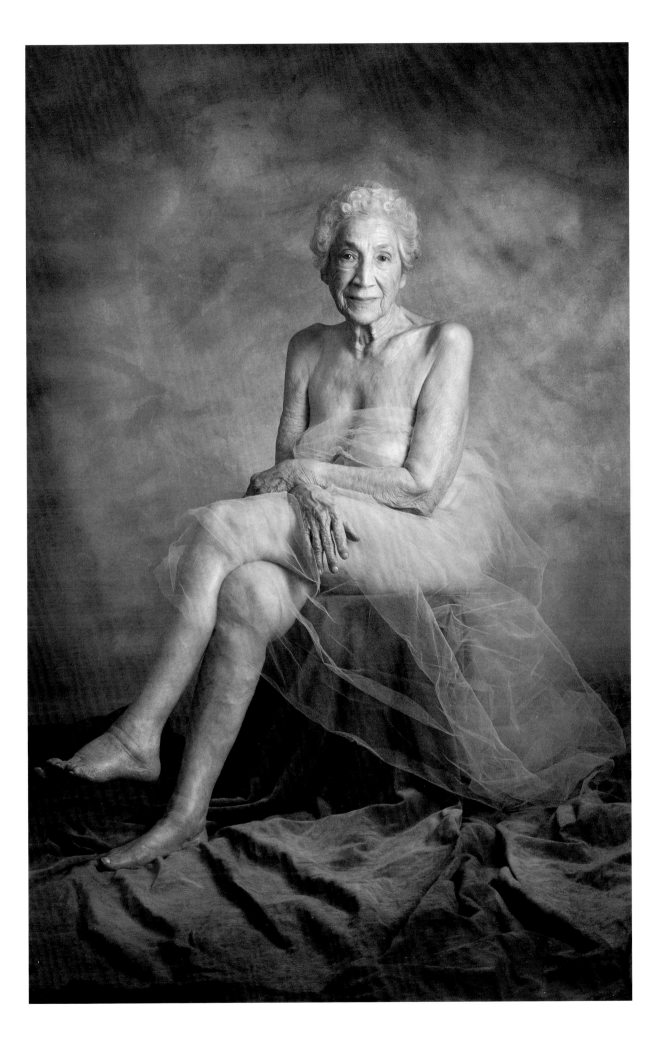

ACKNOWLEDGMENTS

My appreciation to all of the beautiful and courageous
women who agreed to participate in this book, with the hope
that their stories will be helpful to others. Also, to the women
at Artisan who worked carefully to bring my vision for this book
to life. And to the following people who offered help and inspiration:
Mary D. (1956–2002), Carol Bradbury, Gretchen McKay (1961–2005),
Marty Pedersen, Sarah Patillo, Brian Lanker, Duncan McDonald,
Peggy Northrop, Bob Morton, Sarah Lazin, Ann Bramson,
Laurie Orseck, Rita Charon, Gail Smith, and Tom Wear.

Phenomenal Woman

MAYA ANGELOU

Pretty women wonder where my secret lies.
I'm not cute or built to suit a fashion model's size
But when I start to tell them,
They think I'm telling lies.
I say,
It's in the reach of my arms
The span of my hips,
The stride of my step,
The curl of my lips.
I'm a woman
Phenomenally.
Phenomenal woman,
That's me.

I walk into a room
Just as cool as you please,
And to a man,
The fellows stand or
Fall down on their knees.
Then they swarm around me,
A hive of honey bees.
I say,
It's the fire in my eyes,
And the flash of my teeth,
The swing in my waist,

And the joy in my feet.
I'm a woman
Phenomenally.
Phenomenal woman,
That's me.

Men themselves have wondered
What they see in me.
They try so much
But they can't touch
My inner mystery,
When I try to show them
They say they still can't see.

I say,
It's in the arch of my back,
The sun of my smile,
The ride of my breasts,
The grace of my style.
I'm a woman

Phenomenally.
Phenomenal woman,
That's me.

Now you understand
Just why my head's not bowed.
I don't shout or jump about

Or have to talk real loud.
When you see me passing
It ought to make you proud.
I say,
It's in the click of my heels,
The bend of my hair,
the palm of my hand,
The need of my care,
'Cause I'm a woman
Phenomenally.
Phenomenal woman,
That's me.

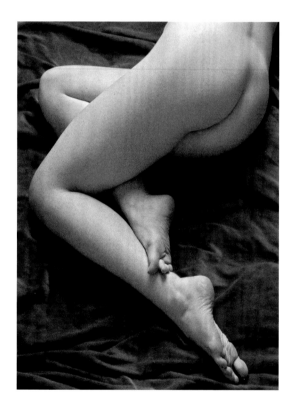